TATTOOS
An Illustrated History

Tina Brown

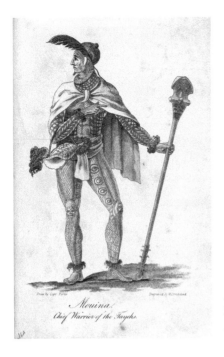

Mouina, chief warrior of the Tayehs from Ua Huka, by Captain David Porter. (Image kindly supplied by The Wellcome Trust)

To William, Mack, Jay, Darrell, Quentell and Brandon – friends brought together by an appreciation of tattoo art.

First published 2018

Amberley Publishing
The Hill, Stroud
Gloucestershire, GL5 4EP

www.amberley-books.com

British Library Cataloguing in Publication Data.
A catalogue record for this book is available from the British Library.

ISBN 978 1 4456 8017 0 (print)
ISBN 978 1 4456 8018 7 (ebook)

Origination by Amberley Publishing.
Printed in Great Britain.

Contents

Introduction

This book is the story of tattoos, from their humble beginnings to the modern day and every era in between. This is the story of the beautiful art that has spanned centuries and the influence tattooing has had globally. This book is not set out in strict chronological order; however, you will find a timeline at the beginning of the book to help guide you, with more information regarding tattoo themes and chapters on specific areas following later, as this was felt to be the best layout and easier to read for the tattoo lover. The timeline will highlight particular eras of tattooing secrets, which will be followed by a look at themes and subjects in more detail; including, for example, how inks have developed and the emergence of prison tattoos from Victorian England to the United States, as well as their common elements.

The book does not look at just the history of British tattooing, but looks to cover the subject more widely and, allowing the influences from around the world to link to British tattooing art, it felt more complete to tell the story in that way. Each chapter's subject matter is worthy of its own book, since there is so much valuable historical information to be found.

It is estimated that some 10 per cent of the adult population in the UK have tattoos of some sort and numbers are thought to be roughly the same throughout the USA. More and more women are getting tattoos today and this has not been seen to change when there has been an economic downturn. People will always find the means to pay for a tattoo – even if it means they go without paying the rent! Tattoos are addictive to the true enthusiast, with many people having numerous designs on their body and actively planning the next.

So what started this art form? Where did it all begin and what do the designs mean? Join me as we discover this and more stories of elaborate artwork through the ages and all that is associated with tattooing, from ancient times to modern-day medical tattooing. Throughout the chapters, the sections have been illustrated with examples of beautiful work by some of the artists, who relate their own stories towards the end of the book. In other areas of the book you will find illustrations of historical importance.

The interest and popularity of tattoos is here to stay, whether you love them or hate them. They form part of who we are, the individuals who choose to wear them and the society they belong to. They are indeed an invaluable living history.

The changing attitudes and beliefs around the subject of tattoos are themselves fascinating; from an art form that had humble beginnings, as a means of identification, to designs created especially to represent the time an inmate spends in prison, to more

recent times when businesses have developed from the art in the form of tattoo studios, schools and media. Also interesting is how the view of tattooed women has changed, moving from tattooed Victorian ladies being looked upon with certain distaste, but also a certain degree of curiosity, to tattoos being the sign of a prostitute, and the role women have since had in winning greater acceptability, from famous female tattoo artists in the 1950s to modern-day women who are very much part of the industry and who are tattoo customers just as much as men.

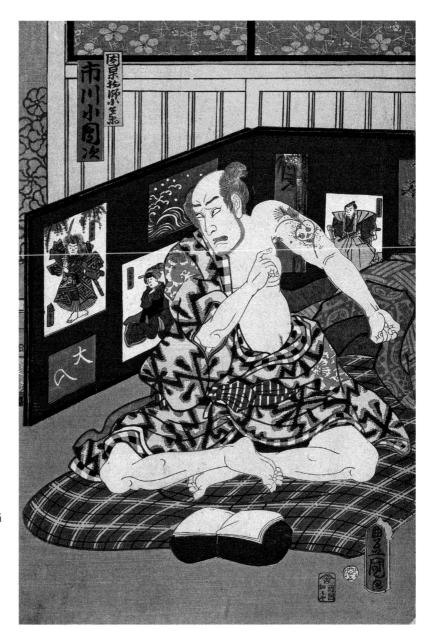

Actor Ichi Kawa Kodangi revealing a tattoo of a skull, *c*. 1861. (Image kindly provided by the British Museum)

A Tattooing Timeline

The Ancient Art

In Ancient China, tattoos were considered to be barbaric practice. However, some depicted bandits and folk heroes.

In South America, preserved skin dating to 6000 BC shows examples of early tattooing, and tattooing tools have been found in the region dating to 60,000 years ago.

In Ancient Egypt, the majority of tattoos were found on females, who had tattoos for healing, religion and as a form of punishment. In fact, the first tattooed mummy to be found in Ancient Egypt was female. Mummies show many tattoo styles in the form of tattooed talismans and Brides of the Dead, who would accompany a man to the next life when he died, have been discovered with tattoo designs comprising a series of dots and dashes displayed on the abdomen and legs. The Egyptians also used tattooing to mark their cattle as a form of identification in 2000 BC, to prevent theft of these previous animals.

In India, tattoos have been used as cultural symbols among many tribes, as well as the caste-based Hindu population. Henna and Mehndi were popular in Ancient India and Egypt and remain popular today in the Indian subcontinent, as well as the Middle East and Northern Africa. It would tell you the status of that individual. In Taiwan, the facial tattoos of the Atayal tribe are used even today to demonstrate that an adult man can protect his homeland and that an adult woman is qualified to weave cloth and perform housekeeping.

Throughout Persia statues and stone carvings from 550 BC indicate the existence of tattoos and piercings.

Pre-Christian Germanic, Celtic, central and northern European tribes were heavily tattooed. Tattooing was common among certain religious groups in the ancient Mediterranean world. However, during the classic Greek period, the only people who had tattoos were the slaves. The fifth-century BC Greek historian Herodotus records how Histiaeus of Miletus, who was being held against his will by King Darius of Susa, sent a tattooed secret message to his son-in-law, Aristagoras. Histiaeus shaved the hair of his slave and tattooed the message onto the man's head. The slave was told that the procedure would cure his failing eyesight. When the slave's hair had grown back sufficiently to hide the tattoo, he was sent to Aristagoras, who shaved his head and read the hidden message, which instructed Aristagoras to begin a rebellion. During the 700 BC period, both Roman and Greek slaves would commonly be tattooed.

Romans generally hated tattoos and anyone with them would have been banished from their city. The Romans had a simple view of life and the body, considering it as being sacred and pure, and this can be seen in the interpretations of the human form in many of their sculptures. In Ancient Rome the tattoo was a way of branding shame onto criminals. Doctors of the time were often asked to tattoo criminals and slaves, and their medical equipment doubled up in these cases as tattooing instruments.

During the fourth and fifth centuries, tattooing in the West almost died out, apart from with the early Christians. There is even reference to tattoos in the Bible, and Saint Paul was said to have had tattoos similar to the wounds suffered by Jesus. During the fourth and fifth centuries Christians used the tattoos to identify who was and who wasn't a true Christian, many displaying a small cross on the inside of a wrist, and this was part of a powerful belief system.

Such tattooing was particularly practised by the Christian Egyptians, whose religious tattoos demonstrated the lifelong commitment of the wearer to the teachings of Christ.

Up to the Eighteenth Century

Tenth-century Scandinavian tribes had tattoos stretching from the fingernail to the neck in dark blue tree patterns and other figures. Throughout Europe, tattoos were looked on as paganism and were legally prohibited in heavy Christian areas. Many Anglo-Saxon kings of England were tattooed, including one of the most famous, King Harold, whose

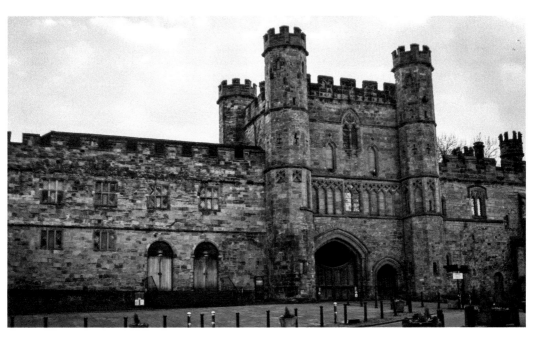

Battle Abbey, East Sussex, was built following the downfall of King Harold in 1066. King Harold's body was identified by the tattoo over his heart. (Image kindly provided by Jason Neale)

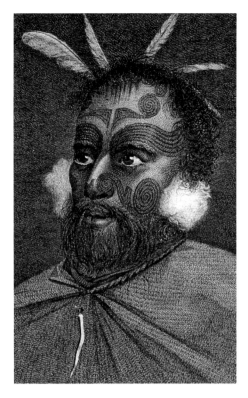

A New Zealand man, possibly Maori, encountered by Cook during his expedition, 1772–75. Engraving by W. Hodges, 1 February 1777. (Image courtesy of The Wellcome Collection)

body was identified by some marks on his skin after he had fallen on the battlefield at Hastings. Some accounts are that his wife, Edith, was asked to identify him after he was fatally wounded. She was able to do this by looking for a tattoo positioned over his heart which read 'Edith and England', signifying how important both of these were to the king. It was during this period that it was common to find soldiers marked with the Jerusalem Cross, to protect them when venturing into battle.

It was during the 1600s that the art of tattoos begun to grow in Japan, which continued until the mid-1800s. During this time the art was practised mainly by manual workers, firemen and prostitutes to communicate their status, which was not perceived as a positive thing, and so would act to warn others of your trade.

There are many different stories attached to the origins of the word tattoo itself and some believe that it originated from the Samoan word *tatau*. When Dutch ships landed in the Samoan islands in the 1700s crew members wrote that they had met the local people, who wore very artfully woven silk tights and knee breeches. These were in fact tattoos. The islanders' tradition of applying tattoos has changed very little over 2,000 years with the skills being passed from father to son, using boar teeth and turtle shell as tattooing tools. A traditional Samoan body tattoo takes weeks to complete and gaining one is a very painful experience.

From the mid- to late eighteenth century to the middle of the nineteenth century, high-profile individuals were turning to tattoos, and these were not always kept under cover. Andrew Jackson (1767–1845), the seventh President of the USA, had a tattoo of a

large tomahawk on his inner thigh area, while James K. Polk (1795–1849), the eleventh President, had a Chinese symbol which translated to 'eager'.

The nineteenth century saw sailors and soldiers adorning their bodies with tattoos and their popularity grew among them. Earlier, in the eighteenth century, Captain James Cook made voyages to the South Pacific. The crew told tales of the tattooed savages they had seen. The word tattoo was introduced into the English language by Cook's expeditions.

From the 1850s onwards tattoos would appear much more in the public eye, with artists who had them being very highly paid. This in turn led to tattoo shops popping up in the USA and UK, with the first tattoo machine being invented in 1891. Despite the spread of tattooing among British society, it was still largely associated with sailors and the lower or even criminal class. But tattooing had been practised by public schoolboys from at least the 1840s and by 1870 it had become fashionable among some members of the upper classes, including royalty.

By 1898 it was estimated that one in five members of the gentry was tattooed. In fact, both Edward VII and George V had tattoos. Many royals had a tattoo of their coat of arms. In an interesting divide, the upper and lower classes found tattoos attractive whereas the middle classes rejected them.

 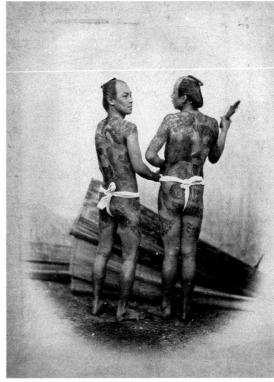

Above left: A naked lady covered with floral tattoos. Etching by an unknown artist. (Image courtesy of The Wellcome Collection)

Above right: Two tattooed Japanese men, *c.* 1800. (Image courtesy of The Wellcome Collection)

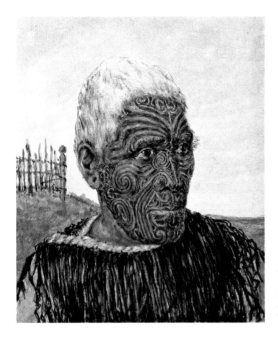

Te Manawa: an Arawa Warrior, a painting by H. G. Robley depicting Maori facial tattoos. (Image courtesy of The Wellcome Collection)

From the mid-eighteenth century in Japan, tattoos really took off, despite them being forbidden. They grew in popularity out of the fact that only those of royal blood at the time were permitted to wear highly decorative kimonos. This led to much unrest and out of this repression grew ingenuity and rebellion, with people getting their whole body elaborately tattooed in response. In 1870 the Japanese government stepped in and outlawed tattoos. This pushed the tattoo artists underground as their art was seen as flouting authority, which also applied to anyone who wore them. For many, however, the tattoo was a badge of honour, with many people looking to the heavily tattooed, highly regarded characters in the novels of the period. In Japan to this day getting a tattoo is considered a serious lifetime commitment, and it is not to be taken lightly. Designs have deeply significant meaning to the wearer and are chosen to represent purity or wealth. It is believed that they transform both life and soul.

Other well-known people from this period had tattoos and this included John Wilkes Booth (1838–65), who is best known for shooting President Abraham Lincoln. John had a tattoo of his own initials on his hand, which was something of a tradition with many actors at this time.

R. H. Macy (1822–77) was the founder of Macy's department store. The design for the department store's logo came from the tattoo of a red star the founder had on his arm, which he acquired when he was a sailor.

The 1800s also saw the start of the trade of tattooed heads, which were acquired by European sailors on voyages to the central and southern Pacific Islands. Often the Maori people were murdered for their heads as the popularity for this grew throughout Europe. The Maori people in New Zealand tattooed their heads (*moko*) and buttocks by chiselling a design into the skin and rubbing ink into it. If one of their chiefs died, they would remove and preserve the tattooed head, keeping it as a treasured possession.

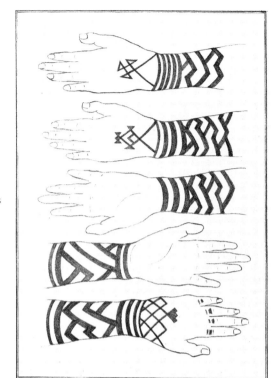

Right: Decorative wrist tattoo designs dated 1873–76. (Image courtesy of The Wellcome Collection)

Below left: Black and white photograph of a Dayak man, the native people of Borneo, showing tattoos on his arms and thighs.

Below right: A tattooed plaster cast face mask of a Maori man. (Image kindly supplied by The Wellcome Trust)

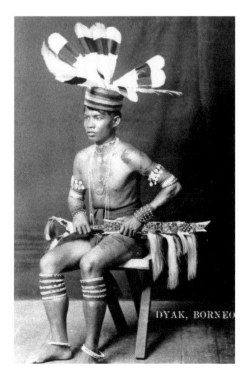

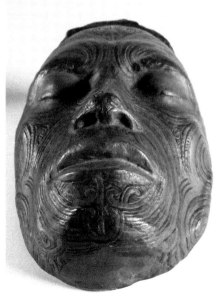

A642970

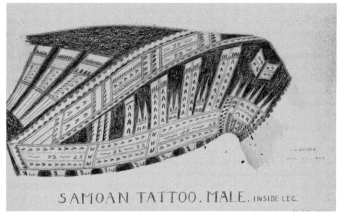

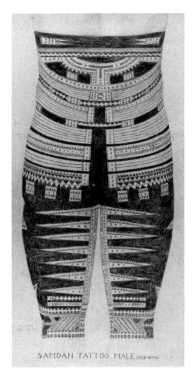

Above: Samoan tattoo drawing. (Image kindly supplied by The Wellcome Trust)

Left: Samoan tattoo drawing of the inside leg. (Image kindly supplied by The Wellcome Trust)

Europeans considered these heads to be curiosities and before long a trade sprang up, with the Maori exchanging heads for firearms. Soon the Maori began to trade the heads of their enemies killed in battle, but when demand started to exceed supply men began to be murdered in cold blood for their tattoos. In some cases, slaves were tattooed so that their heads could be cut off and sold. In 1831 Governor Darling of New South Wales took steps to outlaw the practice.

In England, a report in the *Hull Daily Mail* dated 29 August 1898 reported that the body of a young lady had been found drowned in the river. It was estimated that she was around twenty-five years of age. Her body had been found in the Thames and was awaiting on an inquest. However, what was unusual about her was that she was extensively tattooed in blue ink.

The Twentieth Century

The start of the 1900s saw the subject of tattoos being discussed more openly than before and there was a shift in attitude to tattoos. The newspaper *Greenock Telegraph and Clyde Shipping Gazette* actually carried an advert for the art in 1905: 'Palmistry and Tattooing, Madame Robene in attendance daily from 8 till 10pm, also Prince Vallar, tattoo artist. Can be found near Main Street.'

In 1907 the magazine *The Sketch* carried an image on the cover of Princess Waldemar of Denmark, showing her tattoo, which was an anchor in design. She'd had the work

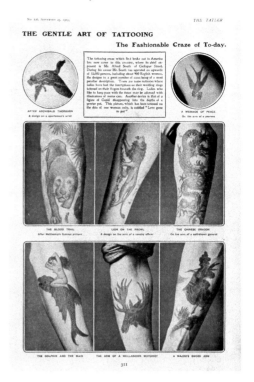

'The Gentle At of Tattooing', a magazine article from 1903. (Image kindly supplied by The Wellcome Trust)

carried out when she was in the Far East. In the early 1900s there was great interest in the Far East, with many more people being able to travel and explore more of the world than before, bringing back mementos of their travels. Princess Waldemar was described as being the only tattooed royal lady of the time.

A London magazine dated 1903 described how tattooing was the fashionable craze of the day. It is described as coming from the USA to the UK, with its chief practitioner being Mr Alfred South of Cockspur Street, London. During his time Mr South operated on upwards of 1,500 persons, including about 900 English women, the designs in a great number of cases being of a most peculiar description. There were some instances where ladies had the inscriptions on their wedding rings tattooed on their fingers beneath the ring, while others, who liked to keep pace with the times, were adorned with designs of motor cars.

In 1929 one appearance of tattoos in public was written about in the *Sheffield Daily Telegraph* on 19 January, when it was reported that Lord Lonsdale was in shirt sleeves at a dinner that the Duke of Montrose and Sir Ian Colquhoun also attended. It was reported that they caused quite a stir when they removed their jackets, pulled up their shirt sleeves and revealed their tattoos. The Duke of Montrose had become interested in tattoos some years prior when visiting Australia and out of curiosity he went into a tattoo shop to see how it was done. He felt that the only real way to experience a tattoo was to have one done himself, so he did.

It was also during 1929 that Peter Johnston-Saint, a purchasing agent of Henry Wellcome, purchased some 300 preserved tattooed human skins from a Dr La Vallette,

an old osteologist at Rue de l'École-de-Médecine, Paris. So who was Dr La Vallette and why did he have this collection of tattooed human skin? In the late nineteenth century tattoos were of great interest to criminologists as they were making a connection between tattoos and crimes. Many scholars also believed that the presence of tattooing in European culture represented some sort of dangerous degradation within their populations. Was this how this intriguing collection ended up where it did?

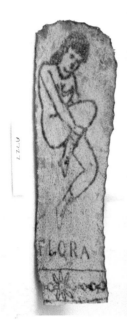

Left: A tattoo on human skin of a nude female named Flora. (Image kindly supplied by The Wellcome Trust)

Below: Human skin tattooed with an eye. (Image kindly supplied by The Wellcome Trust)

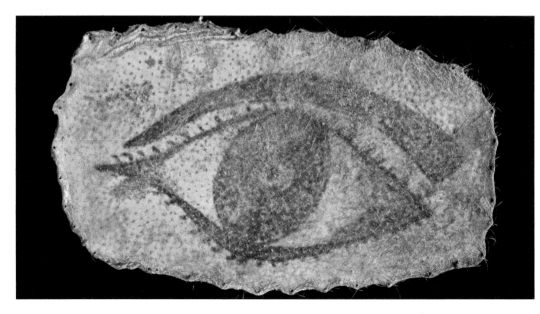

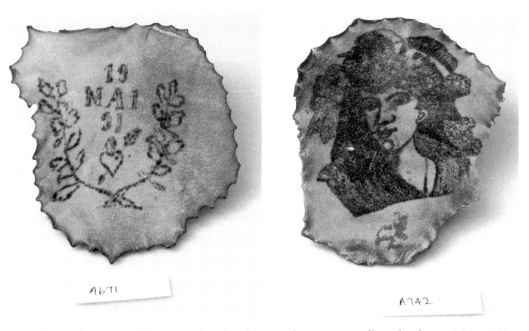

Above left: Human skin tattooed with a heart and arrow, as well as the date: 19 May 1891. (Image kindly supplied by The Wellcome Trust)

Above right: A woman's face tattooed on human skin. (Image kindly supplied by The Wellcome Trust)

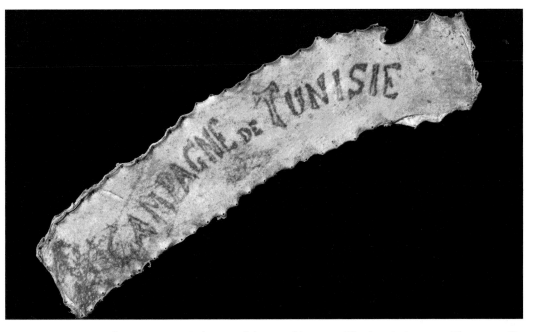

Inscription on skin, *c.* 1860–90, immortalising world events. The inscription says 'Campagne De Tunisie'. Tunisia was part of the French Empire in 1881. (Image kindly supplied by The Wellcome Trust)

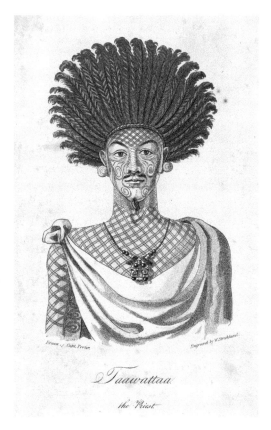

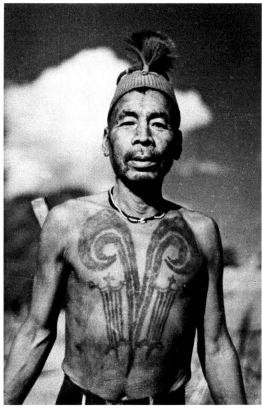

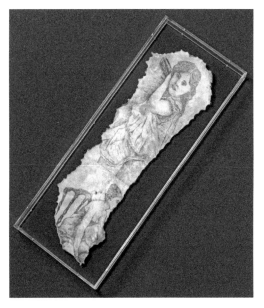

Above left: Taawattaa, the priest from Madison Island, drawn by Captain David Porter. (Image kindly supplied by The Wellcome Trust)

Above right: Chang Naga with a headhunter's breast tattoo, photographed by Christoph von Fürer Haimendorf in 1937. (Image kindly supplied by The Wellcome Trust)

Left: Figures of women tattooed on human skin, *c.* 1880–1920. (Image kindly supplied by The Wellcome Trust)

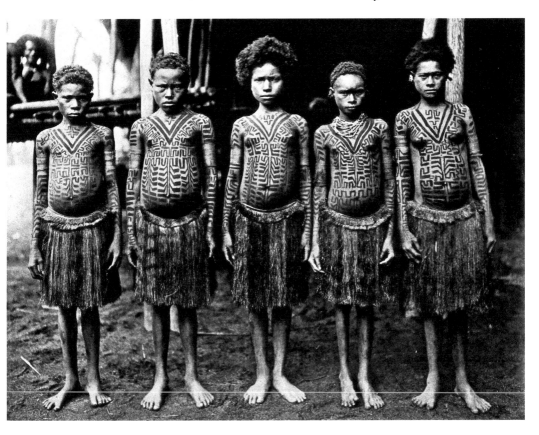

Above: Tattooed girls of Waima Village, New Guinea, photographed by H. M. Dauncey. (Image kindly supplied by The Wellcome Trust)

Right: A tattoo on human skin reading 'Delacour 1862' below the image of a blacksmith. Another part of the collection held by Dr La Vallette. (Image kindly supplied by The Wellcome Trust)

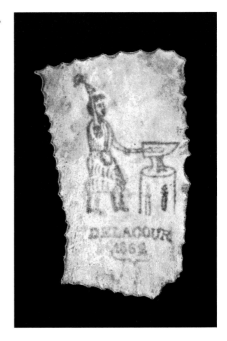

One tattoo artist who is deserving of a mention is Jessie Knight, as she was monumental in what was to be the emergence of female tattoo artists in the UK. She had a very successful career from the 1920s to the 1960s. Although her father had been a tattoo artist, she was not trained by him, but instead started to work under Charlie Bell of Chatham, Kent, and established her talent in her own right. Jessie was groundbreaking in opening up a world that had previously been dominated by men.

In October 1991 a remarkable discovery was made – the 5,300-year-old frozen body of a Bronze Age man who was assumed to be a hunter. He was found close to the Austrian and Italian border and his body displayed several tattoos. He was called Ötzi by those who discovered him and he was so well preserved that scientists were able to make out and identify many of the tattoos he had. He had a cross on the inside of his left knee, lines on the abdominal area and lines on his ankles.

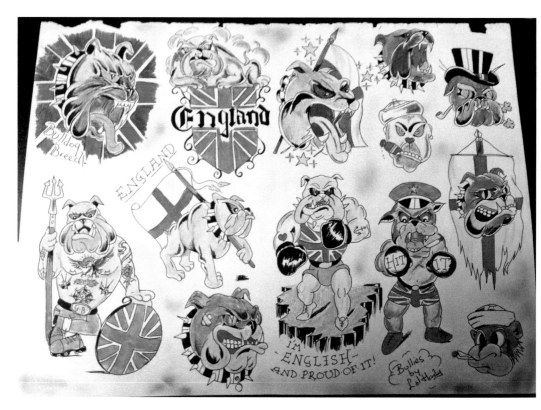

Vintage bulldog tattoo designs, kindly supplied by Lal Hardy from a private collection dated *c*. 1980s.

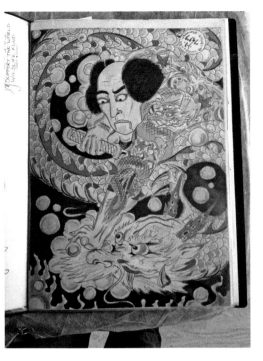 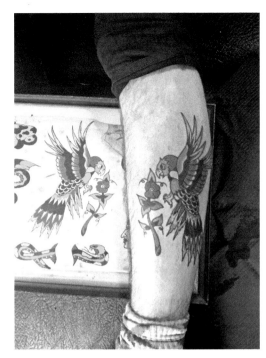

Above left: An intricate Japanese dragon design, kindly supplied by Lal Hardy from a private collection.

Above right: A brightly coloured bird, both its design and finished tattoo, kindly supplied by Lal Hardy from a private collection.

A tattoo advert for George Bone of London, kindly supplied by Lal Hardy from a private collection.

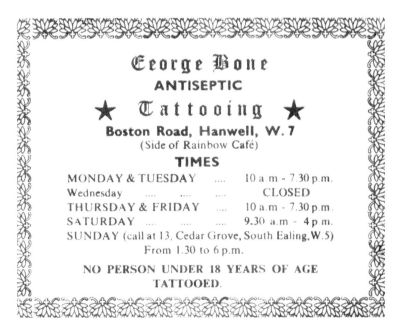

George Bone
ANTISEPTIC
★ Tattooing ★
Boston Road, Hanwell, W.7
(Side of Rainbow Café)
TIMES

MONDAY & TUESDAY	10 a.m - 7.30 p.m.
Wednesday		CLOSED
THURSDAY & FRIDAY	10 a.m - 7.30 p.m.
SATURDAY		9.30 a.m - 4 p.m.
SUNDAY (call at 13, Cedar Grove, South Ealing, W.5)		
From 1.30 to 6 p.m.		

NO PERSON UNDER 18 YEARS OF AGE
TATTOOED.

War and Military Tattoos

Professional tattooing was well established in the United States and the United Kingdom by the start of the twentieth century and had become a popular art form for any member of the armed force, and particularly for sailors around the world. A. T. Sinclair, writing for *American Anthropologist* in 1908, stated that a full 90 per cent of American sailors were tattooed.

Interestingly, in 1909 a flyer from the United States Navy stated that indecent or obscene tattooing was a cause for rejection, but applicants should be given a chance to alter the design so they could enter the navy. It is unknown if the navy relaxed this policy after the start of First World War.

Many tattoo designs from the First World War were left over from the Spanish American War (1898). Those patriotic, sentimental, religious, heroic, nautical and friendship-based designs seemed to be universal no matter what war was being fought. Often all it takes is a subtle change to update an image and make it look more modern, like the hairstyles on pin-ups, the types of hats on sailors or the type of ship shown on a chest piece.

For many First World War soldiers there was one thing that helped them both bond with comrades and remember their families – a tattoo. It was one George Burchett, a London cobbler, who they called on to get their tattoos. 'The reason why soldiers want tattoos is, on a really basic level, it's the fighter instinct, it's the warrior within us and warriors have always decorated themselves,' says Dan Gold in an interview for the BBC, who took inspiration from Mr Burchett. 'To get tattooed is almost like putting on armour; you feel stronger once you've got it.'

Burchett was something of a celebrity tattooist in his day and he had some strange jobs along the way. One man wanted a portrait of King George V tattooed on his bald head, and at the request of a father heading for the front line, he also put a shamrock and thistle on the arm of a nine-year-old girl: 'Without a flicker that child put her little arms on the table, and never even winced. Proud as punch she was when it was all over, because "Daddy wanted it done."'

Born in 1872, Burchett joined the navy when he was sixteen years old. With the navy he travelled the world, and in Japan he got his first tattoo. Life in the navy did not suit him, however, and he soon deserted. With a tattoo machine given to him by a shipmate, he ended up in Jerusalem, where he set up a business tattooing pilgrims who were visiting the sites where Jesus is said to have been crucified and buried. Once there, Burchett's business mind came into its own and he marketed himself as the only

British – and hygienic – tattooist in the city. This did not always go down very well with locally established artists.

It was not long before Burchett decided to return to England and it was here that he set up his own cobbler's business in Mile End, London. The word soon got round that he had a tattoo machine in the back room. Bit by bit his reputation as a tattoo artist grew and he saw that he was making more from tattoos than repairing boots and his most common tattoo requests came from military personnel. Before long Burchett was extremely popular and he moved to new premises in Lambeth Road, close to Waterloo Station – the station that many soldiers were heading to the front line from during the First World War. Burchett's small business grew, with queues forming round the block, morning and night. British and Allied forces found a common subject to chat about while waiting to get their tattoos and this, for a short time at least, took their minds off what might lie ahead of them. Burchett appreciated and understood that by having a powerful, meaningful tattoo, it gave a lot of strength to many at times when they needed it the most.

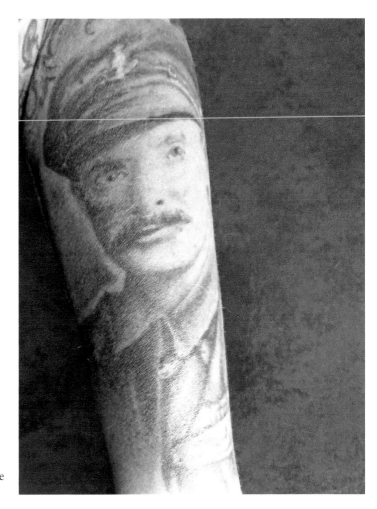

A Second World War memorial tattoo in black and grey showing a soldier from the Green Howards. (Author's own tattoo by Magic Needle, Vrasta, Bulgaria, depicting Yorkshire Regiment, Green Howards from the Second World War.)

Following the war, the sombre mood that hung over millions meant that designs changed again, this time to memorials – images of graves, crossed flags and representations of the unity of nations. The tattoos of this period told their own stories, reflecting the pain and the change in mood of a nation. This work carries on to this day, with many modern-day soldiers getting tattoos with the same meaning and sentiment as those by Burchett.

Designs of military flags are still highly popular. To many a flag may be viewed as a simple piece of coloured cloth that is individual to a country and may not bear that much meaning. However, to others the symbol of the flag has deeply significant meanings, such as protection, victory, pride, honour, loyalty and hope. The flag has been used by countries to express the love of their land by hoisting flags. At the same time, victorious armies have used the flag to show their enemies who the winners are by displaying captured flags.

It is uncertain what date the earliest flags appeared, but it is believed that the first designs used themes from the natural world, with wild animals being the most popular. It is thought that flags were first used to identify the enemy and to assist with movements on a battlefield. They were also used to signal to ships and to show identification. There is no doubt that the flag has its own place in tattoo history given its heritage and symbolic meaning.

Tattooed skin displaying French flags and a badge of honour, *c.* late 1800s. (Image kindly supplied by The Wellcome Trust)

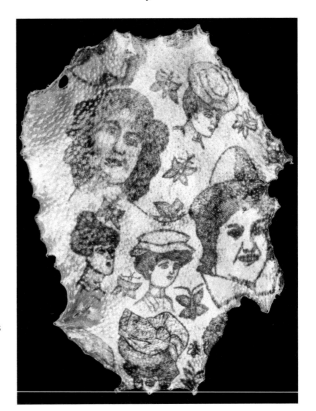

Human skin showing tattooed images of women's heads – you can't help but wonder who the ladies were and what stories were behind these designs. (Image kindly provided by The Science Museum, London)

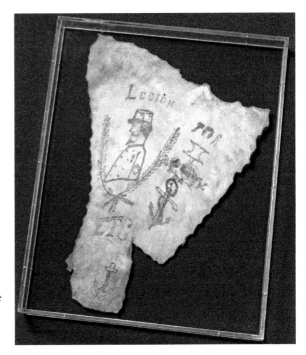

A tattoo on human skin showing a soldier, displayed with a badge and an anchor. This was part of the collection held by Parisian surgeon Dr La Vallette from dead soldiers. (Image kindly provided by The Science Museum, London)

The Circuses of Europe and America

British and American Tattoo Attractions

During the late nineteenth and early twentieth centuries, tattooing and circuses went hand in hand. When one flourished so did the other and, likewise, when a circus faced bankruptcy, this had a knock-on effect on many tattoo artists.

The idea of showing tattooed men to a fee-paying crowd was born out of European visitors to the South Sea Islands. The connection between tattooing and the circus began in 1804, when Jean Baptiste Cabri – who had been tattooed by the people of the Marquesas, and who in turn learned the art from them – returned to England and became a carnival performer. He was also able to replicate the tattoos for an audience and his popularity grew. In the last years of his life, however, he was forced to compete with trained dogs and other popular amusements in country fairs, and in 1822 he died, poor and forgotten.

The first tattooed English showman was John Rutherford. It was said that he was captured and held prisoner by the Maoris. During his years with the Maoris he participated in warfare, headhunting, and other tribal activities. When he returned he accompanied a travelling caravan of wonders, where he showed his tattooing and told of his adventures.

It is thought that the sideshow was born around 1840, when individual acts were grouped together under one tent. Before this time, small people, tattooed people, sword swallowers and other attractions of this nature were exhibited singly in pubs, theatres and the like.

The great nineteenth-century showman P. T. Barnum is credited with organising the first group exhibitions of unique individuals. One of the principal attractions at Barnum's American Museum in 1842 was James F. O'Connell, who had the honour of being the first tattooed man ever exhibited in the United States. He entertained his audiences with tales of exotic adventures and, according to O'Connell, savages on Ponape, in the Caroline Islands, captured him and forced him to submit to tattooing at the hands of a series of voluptuous virgins. He was forced to marry the last one to have tattooed him. Museum patrons, most of whom had never seen tattooing before, were impressed.

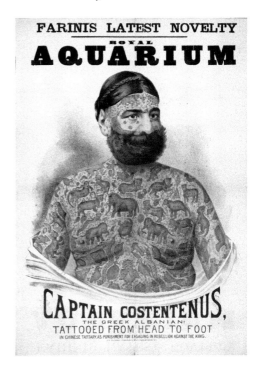

Captain Costentenus, who was famous for being tattooed from head to foot.

Later, in the 1880s, P. T. Barnum exhibited and exploited George Costentenus, whose skin was the most completely and elaborately tattooed that had been witnessed in America and Europe.

Rival circuses competed with each other for the services of the most elaborately tattooed show people and paid them handsome salaries. Many tattoo artists of the time made most of their money while travelling with circuses during the spring and summer, returning to their shops and homes in the winter. The circus served as a showcase where tattoo artists could attract customers by exhibiting their work to a paying public, and in many cases the only surviving records are in the form of the photographs and posters that were used for circus publicity.

Maud Wagner was famous as a circus performer in the early part of the twentieth century, being best known for her acrobatic and contortionist acts. She met Gus Wagney, a tattoo artist, and it is said that she only agreed to date Gus if he gave her lessons in how to tattoo. Maude progressed to becoming a very well respected tattoo artist and she and Gus ran a very successful business together. The couple had one daughter, Lotteva, who continued the business until the 1980s.

Another famous tattooed lady was Betty Bradbent (1909–83), who was raised in Philadelphia. She performed with major circuses in the USA, Canada, Australia and New Zealand. The story says that Betty became fascinated in the art of tattooing when she met Jack Redcloud, a tattoo artist, at the age of fourteen. At the age of sixteen she had her own collection. In 1940 she married circus sideshow manager Charley Roark, which sadly ended in divorce. Betty married her second husband in 1969, Winford Brewer.

There are many accounts of Horace Ridler, also known as the The Great Omi, or the Zebra Man, who was the most famous tattooed man in the UK in his day. In 1927 he asked London's leading tattoo artist, George Burchett, to tattoo him all over, including his face, with inch-wide zebra stripes. Ridler also had his teeth filed down to sharp points, had his nose pierced so he could insert an ivory tusk and his ear lobes pierced and stretched. To become a freak in order to earn a livelihood was a gamble that might not have paid off, but Ridler became one of the most successful freaks in the history of the circus, succeeding because he was unique. During the latter part of his career, however, there were fewer and fewer tattooed people seen in circuses; the popularity of the freak show was waning and tattooed people were no longer seen as novelties. After the Second World War, freak shows came under attack and only a few of the larger circuses still included them.

Today it feels quite uncomfortable to think that individuals were put on show in this way due to their desire to ink their skin to be different and unique. However, whatever you feel about this subject, a visit to the circus to view the tattooed people was a very popular form of entertainment, and by the end of the 1920s there were more than 300 fully tattooed people employed by the travelling circus. For many of the individuals the circus would offer them a place of safety, away from the comments of middle class society, somewhere that they could show off their art in a welcoming environment with likeminded people around them.

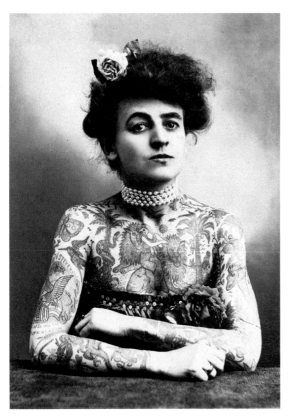

Maud Wagner, photographed *c.* 1911. Wagner was one of the most tattooed ladies of all time.

26

German Tattoo Attractions

Germany has a long and colourful history of body decoration. In 1988, a carved figure of a man was found in a cave at Hohlenstein-Stadel, Germany. It was carbon dated at an amazing 32,000 years old and was marked with thin lines running along the upper arms.

Friedrich Barbarossa ('Red Beard'), Holy Roman Emperor and King of Germany from 1152 to 1190, is often seen in illustrations with cross designs on the back of his hands. Kaiser Wilhelm II, Emperor of Germany, was rumoured to have an eagle tattooed on his chest.

We should not forget that the first professional tattooist in the United States was Martin Hildebrandt, a German immigrant. Nora Hildebrandt, Martin's daughter, is credited as the first female attraction in the United States. In the 1860s she also had the grand title of being the first professional tattooed lady and she travelled extensively with Barnum & Bailey's Circus in the 1890s.

There have been many German attractions in sideshows on both sides of the Atlantic. The following are a number of the attractions that originated Germany or were famous there:

Don Manuelo was first known in the late 1800s when he appeared with a full body of tattoo designs, many of which told a story and had deep meaning. On his back he had a large military scene with an eagle and crossed flags. On his chest he had various designs, including sailors, Red Indians and ladies. He also had the interesting design of laced up spats on his lower legs, which was a popular design for German attraction workers.

Nora Hildebrandt first appeared in New York City in 1882. She was known for having 365 tattoos – one for each day of the year. The artist was her father.

Frank and **Emma de Burgh** acquired their artwork in New York City from Samuel O'Reilly. They are featured in many German posters for sideshows and were well known in their circle of work and the tattoo world.

Miss Creola and **Miss Alwanda** were one of the few double attractions in the history of the tattoo sideshow. Most of the artwork they had was of European kings and queens.

La Bella Angora's designs were of a multi-jewelled necklace and a large eagle design located on her chest.

Miss Annie Frank arrived on the tattoo scene in the 1920s. Her tattoos consisted of many patriotic designs, including Lady Liberty, eagles and crossed flags, as well as the required laced-up spats. Her designs were loved by many.

Lyda Akado worked with the American Ringling Bros. and Barnum & Bailey Circus in 1954.

Prison Tattoos

The history behind the prison tattoo is captivating. Many argue that gaining a prison tattoo could be due to wanting a sense of belonging or being part of something, while some may say it's to mark an individual's uniqueness and to make them their own person in a world where they are treated the same as the next inmate serving time. Whatever the story behind the artwork, no history of tattoos would be complete without a chapter on this subject. There has been a long-standing association between tattoos and criminality, or so many would say. However, it is felt that this has more to do with attitudes and stereotyping in the modern world.

It is interesting to learn that when people were charged with a crime in Ancient China they had their crime tattooed onto their foreheads and faces, so that everyone knew what they were being charged with. This brought shame and humiliation to both the individual and their families, resulting in many being cast out from their homes.

During the 1600s branding irons were used to mark felons or deserters in England. The irons were heated before use to inflict more pain. Branding was abolished in 1829 with the exception of army deserters. The mark was then tattooed onto the body, rather than being branded with irons. The practice was totally abandoned in 1878.

There is evidence that between 1720 and 1870 criminals in other parts of the world were tattooed as a visible mark of punishment. The criminal would have a single ring tattooed for each crime. This was eventually abolished and the art of tattooing was banned altogether, being viewed as barbaric and lacking respectability. This created a subculture of criminals and outcasts as these people would have no place in decent society and were frowned upon. They could not fit in mainstream society because of their obvious visible tattoos, forcing them into criminal activities, which, in Japan at least, ultimately formed the roots of the Yakuza, with whom tattoos have almost become synonymous in Japan.

A little closer to home, in the old Cornish town of Bodmin, a gaol (jail) was built in 1779 and was the first modern prison to be specifically designed and built in England. The location of Bodmin Gaol was considered in the early 1800s to be the perfect location, with Bodmin being the 'Gateway to Cornwall'. The gaol was designed to be airy and had a supply of clean water piped through the buildings to provide water for drinking and sanitation. There were separate areas for men and women and each person had their own individual cell for sleeping in. There was also a hospital area for the sick and a surgeon would be in attendance on a daily basis. The gaol also had a chapel, day rooms and workshops on the site. The buildings were elegant and the plan

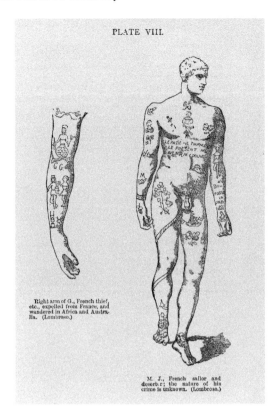

On the left is the tattooed arm of a thief expelled from France and on the right are the tattoos of a French sailor and deserter. (Image kindly supplied by The Wellcome Trust)

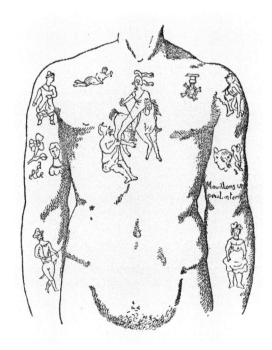

Tattoos from a French glazier, thief and deserter from the army. (Image kindly supplied by The Wellcome Trust)

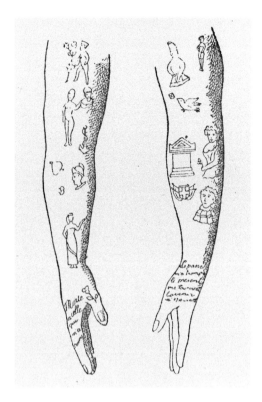

The arms of a criminal whose whole body was more or less covered in tattoos. Little has changed in the modern world, where full-body tattoos are common in prisons. (Image kindly supplied by The Wellcome Trust)

Portrait of a criminal with a tattooed inscription on his chest, with a tattoo of a cross underneath. (Image kindly supplied by The Wellcome Trust)

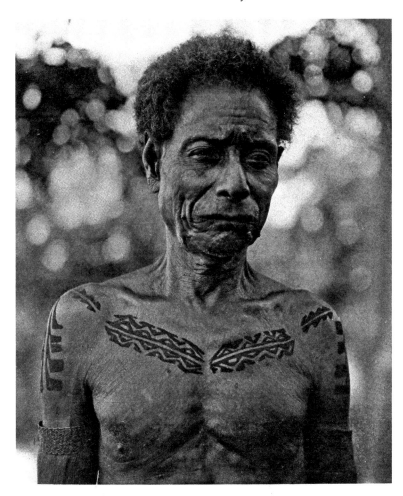

Illustration of tattoo assumed by homicide. Date unknown. (Image kindly supplied by The Wellcome Collection)

Tattoo assumed by homicide

was considered a step in the right direction in the care and also the rehabilitation of offenders. The building had been designed to house 100 inmates; however, this proved to not be adequate, and plans were made to expand the gaol significantly.

For much of the eighteenth century, no one really cared about what happened to the felons who were in Bodmin Gaol or what their lives consisted of. Many felt that they were people from the lowest rank in society and so did not deserve any care. Many were hanged, and some were thrown into dungeons and forgotten about, while others were transported. Many of the inmates held at Bodmin were repeat offenders convicted of petty crimes, such as being drunk and disorderly in the streets, making a noise and nuisance of yourself in public, getting into a fight in public and theft. Inmates were listed and recorded upon entry and on leaving the gaol. Some of the records are very limited in the information that they can provide us, but the information recorded included whether they had any markings or significant scars.

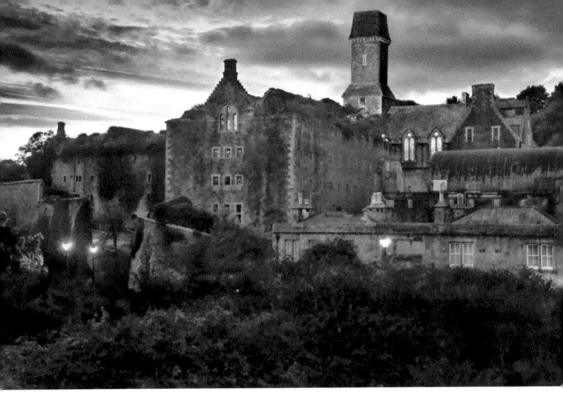

Bodmin Gaol at night – a haunting image of the famous prison in Cornwall.

Upon entry to Bodmin Gaol, full details were taken of all inmates, including any markings, scars or tattoos, before they were put behind bars.

Some prisoners were allowed to work at Bodmin Gaol while others were confined to a life behind bars and the prison door.

There were many places of execution around Bodmin, including the gibbet on the town's common and the scaffold and drop inside the gaol.

Below is some of the information taken from the gaol's records, referring especially to the tattoos each individual inmate had. Each description tells its own story and helps build a picture about the life of the individual at the time:

James Snell, admitted 3 December 1850 for ten years, charged with breaking and entering the house of Mr William Mules and taking a dish. James was marked with the inked words 'King's Evil' on his left thigh.

John Marks, a seaman from Cuxhaven, Hamburg, was admitted to Bodmin Gaol in 1866. John was charged with refusing to proceed to sea on a ship and was thrown in jail. He was marked with several tattoos of a star, an anchor and a ship.

William Sleeman, was admitted to Bodmin Gaol in 1870, having been charged with being absent without leave from the Royal Cornwall Regiment and being drunk. He was marked with a tattoo of a crucifix, a man and a Union Jack.

Mary Tremaine was aged just seventeen and employed as a servant in 1843 when she entered Bodmin Gaol. She was charged with burning oakham in Truro workhouse and causing a distraction. She was marked with the letters 'MAC' below and 'J' above her left elbow.

Henry Willian, aged eighteen, was employed as a shoemaker in 1877. He was sentenced to the treadwheel for assault and causing grievous bodily harm. He was marked with four dots on the hand.

Elizabeth Collins, aged twenty-three and married, was charged with being drunk and disorderly in Truro. Her usual trade was being a hawker (street seller of goods) and she spent time cleaning when she was in the gaol. She was also known as Elizabeth Bray. Elizabeth had several ink markings to her skin but no further details were recorded at the time.

John Cook, aged twenty-three, was recorded as being married and as being a miner from Kea. He was charged with wandering and trading without the proper licence to do so at St Mewan. For this he was sentenced to treadwheel work. John was marked with an anchor and cable tattoo.

Theophilus William Costello, aged thirty, was married and was occupied as a saddler. He was charged with stealing pork from Bodmin and was sentenced to the treadwheel. He was marked with a wreath tattoo.

Susan Luke, aged nineteen, single and recorded as working as a prostitute in 1838. She was charged with wandering the streets of Bodmin. Susan was marked with several tattoos, but no further information is given as to their design or meaning.

Mildred Emlyn Sawdry, aged thirty-two and married, was charged with being a dissenter and causing damage to a house. It was noted in her record that she was not employed due to being 'insane' (mentally ill). Records show that she was once placed in the 'dark cell'. Mildred was marked with the letters 'WHS' and 'FB'.

William Cundy was aged twenty-one and was single at the time of being charged with stealing six barndoor fowl from Mr William Salmon from Bodmin. He was employed as a railway labourer in 1834 and was from St Mawes. William was marked with a star below his left elbow and the letters 'WC' below his right elbow.

Eliza Dorin, aged forty-five, was recorded as being a widow in 1826. She was employed as a charwoman prior to her conviction, wherein she was charged with lodging in an outhouse in St Austell. This was Eliza's sixth time in prison. Eliza was marked with the letters 'WRJB' and 'SMAOS' on her left arm.

Emma Knott was aged twenty-six and was single at the time of her conviction. She was employed as a charwomen. In 1869 she was charged with being a dissenter and for assault and beating. This was her twentieth visit to gaol. Emma was marked with several tattoos, which included the letters 'WS' and 'WB' on her arm.

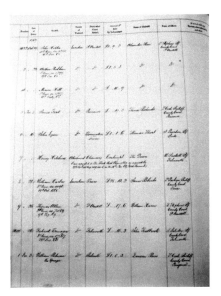

Right: Bodmin Gaol inmate records, kindly provided by Chris Wilkes, Bodmin Gaol.

Below: Bodmin Gaol inmate records, kindly provided by Chris Wilkes, Bodmin Gaol.

An interesting article appeared in the *Mid-Wales Advertiser* in 1899, entitled 'A Tattooed Prisoner'. The article went on to say: 'A man, who appeared to be both a living picture gallery and a good all round thief, was sent to prison for four years at Clerkenwell … The prisoner was tattooed over nearly the whole of his body.' He was described as being extremely decorative and made his living by knocking on doors and offerings items for sale.

There was an interesting article written in the *Daily Mirror* in 1965, which reported on a story of a plastic surgeon who was touring British jails and removing tattoo marks from prisoners to help them forget their criminal past. The Home Office reported at the time that although tattoos were useful in helping police identify suspects, they may be preventing ex-prisoners from making a fresh start in life. One Home Office official reported that tattoos were being removed only on the advice of prison medical officers. The scheme was part of a plan by the Home Office to help criminals lead normal, law-abiding lives when they are released.

Today, there are many meanings in the tattoos that are found around the world in prisons. Some of the most common are as follows:

1488 relates to Nazi/white supremacists, with the '14' relating to the fourteen words quoted by a leading white supremacist, while the '88' symbolises the eighth letter of the alphabet twice, 'HH' standing for Heil Hitler.

A cobweb typically represents a lengthy prison sentence, as well as signifying a prisoner being trapped behind bars. This design is commonly found around the elbow, although it can also be found on the neck. You will rarely find colour tattoos in prison as inmates do not have access to coloured inks, or indeed items to make the colours from.

Teardrop(s) are one of the most commonly recognised prison tattoos. A teardrop tattoo can have different meanings depending where you are; for some inmates it can mean a lengthy prison sentence while for others it's a sign of a murderer. Others say that the symbol is for someone close to them who has passed away and that it is a mark of respect.

A five-pointed crown tattoo relates to the Latin Kings, which is one of the biggest Hispanic gangs in the US, based in Chicago. Their presence is huge both in and out of prison.

Three dots is also another common tattoo and means '*mi vida loca*', or 'my crazy life'. It does not have a gang affiliation but does have connections with the gang lifestyle. The dots are commonly found near to the eye or on the hand. Another meaning for the three dots is a religious significance representing Christianity's Holy Trinity. This tattoo is one of the oldest and most recognised throughout the history of prison ink.

Five dots has quite a different meaning and this relates more to time spent inside. The four dots on the outside represent the four walls, with the fifth inside representing the prisoner. This tattoo is found throughout the USA and in the UK and is found on an inmate's hand, between the thumb and forefinger.

A clock or **timepiece** is a popular tattoo with inmates today. Many of the designs show the clock or watch face with no hands, and this symbolises the time spent inside prison.

La Eme (or **The M**) is the symbol of the Mexican Mafia, which is one of the largest and most ruthless prison gangs in the US. It was started by Mexican Americans when they were incarcerated in American prisons.

Playing Cards are usually found on inmates who like to gamble and can also represent their wearers' attitude to life in general.

EWNM, standing for 'Evil, Wicked, Mean, Nasty'. They are not gang-related and merely the thoughts of an inmate. They are found on the knuckles and were made popular by Robert Mitcham in 1955 in *The Night of the Hunter*.

A cross on the chest represents a 'Prince of Thieves' and is common in Russian prisons. This is the highest rank a Russian convict can achieve and is worn by senior gang members.

ACAB means 'All Cops Are Bastards'. However, some wearers claim it means 'Always Carry a Bible'.

Tattooing is illegal in prison and if you are found to be creating tattoos then you could be sent to solitary as a form of punishment. This of course begs the question – how do such tattoos get done, and what do the inmates use to carry out their work?

How inmates tattoo today is fascinating. I am honoured to have learned about the process from inmates with whom I correspond on a regular basis. They have shared with me the hidden world of modern-day prison tattoos, but the principles and meanings extend back centuries.

The tattoo machines are made using a CD or tape player motor, or any other type of small motor they can obtain, and these are known as 'Pancakes'. Needles are made out of springs, the type that you would find in a pen or a lighter. Otherwise, thin wire can be made into a suitable needle-like device, which can be straightened out with heat and then sharpened with sandpaper. Ink is made from a number of items being burnt to create the pigment.

Mixing up the ink is an art in itself. First, you place a small amount of soot from the burnt item in a toothpaste cap, adding some water, a very small piece of soap and a tiny amount of shampoo. Mix all this together with the end of a pen and you are ready to go. The inmates who shared this information with me stressed that you should never share the equipment with anyone, you should always clean with bleach and a naked flame, and that you always use new ink each time.

For many of them, tattooing is part of their life; it's a way of being individual in a world where they are forced to be the same as thousands of other incarcerated people. They are willing to take the risk to make themselves stand out from others for something they strongly believe in.

The following is what Jay Roddy, an inmate in Georgia, told me about tattoos:

A lot of people don't understand why people would want to put things on themselves that would never come off. That's because they don't ask what the meaning is behind the tattoos. People have been getting tattoos for as long as we can remember. Different cultures have different meanings as well as methods of application – from sharpened needles dipped into homemade ink, to taking a small hammer-like utensil with multiple small needles, or they have a homemade gun made from a small CD player motor with a spring as a needle.

Ever since I can remember I've been into the artwork of tattoos. There is as much joy receiving the work as well as doing it. The feeling and the meaning of pieces are not just a way to express yourself but also have a personal memory that will always be there.

I have had the opportunity to see a lot of amazing work as well as artists. The one thing I love is when I learned to run tattoos, to be able to watch the work come together with the shades the way you can see images in your mind come to life. To see the expression on the face of the person when you have finished and them saying 'OMG, it's better than I thought it was going to be!'

Taking pride in your work is a good thing, to know that you did your best and to know your work not only to satisfy yourself but the person that is getting the tattoo.

Hand branding, used to permanently mark prisoners. (Image kindly supplied by The Wellcome Trust)

Sailors, Ships and Other Nautical Designs

'A sailor without a tattoo is like a ship without grog: not seaworthy.'

Samuel O'Reilly

This subject was briefly touched in the earlier wartime tattoo chapter. However due to the amount of information, I felt it necessary to have a separate chapter dedicated to this subject.

This style refers to tattoos, old-school in design, which were common among sailors. Popular designs included swallows on either side of the chest, girls in sailor hats and pairs of dice. These styles have stood the test of time and have spanned centuries in their popularity.

One tattoo artist best known for this style of tattoo was Norman Collin, better known as Sailor Jerry. He was a well-respected and ingenious designer. During the Second World War in Honolulu, Hawaii, when the red light area was filled with soldiers and sailors preparing to ship out, there was one common bond holding them all together, and that was Sailor Jerry. His reputation and skill were so highly regarded that his tattoos were considered an art form, so much more than the drunken tattoos many soldiers got. However, due to his extreme popularity he came under the scrutiny of the US Government and in the 1950s he was forced to temporarily quit. Following this slight setback, Sailor Jerry continued his art for which he was so well known for, before passing away in 1973 at the age of sixty-two. He is buried in the National Memorial Cemetery of the Pacific.

Sailor tattoos are also a way of preserving the strong culture and tradition connected to sailors' superstitions. Throughout history sailors have always been very superstitious and held certain symbols and items in high regard, hoping they would help them when facing certain events in life. There were symbols that would either attract good luck or back luck. An example of this would be the images of a pig and a hen, both considered wards against drowning. This was because neither animal is capable of swimming and, according to the legend, God would look down upon a shipwreck and see the image of an animal who was not able to swim and would pick the sailor up, saving him from drowning. Another popular symbol is that of the North Star, also known as the compass rose. Sailors believed that wearing this would help them find their way home.

Sailor tattoos grew in popularity in the port areas where sailors would spend time. Due to this the tattoos became associated with the criminals, prostitutes and gangs who lived in these same districts. However, sailors made their tattoos different and gave

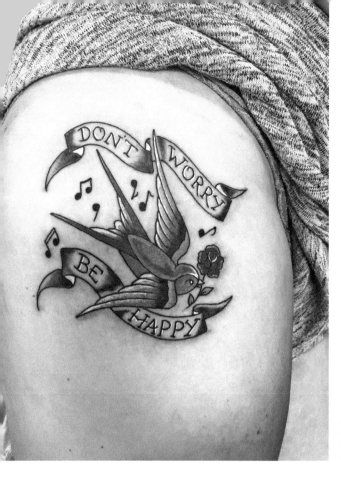

The swallow was used as a symbol by sailors to show off their sailing experience. This design was completed by Lal Hardy.

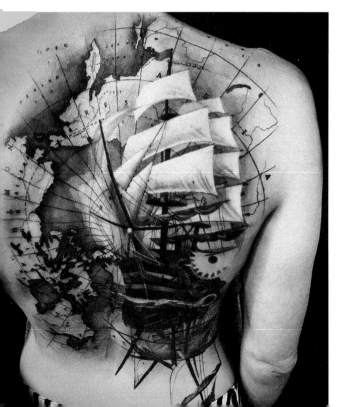

A black and grey ship design showing intricate detailing by Jimi May.

themselves a unique identity, and by the nineteenth century about 90 per cent of all US Navy sailors had tattoos, a number closely followed by British Royal Marines. In 2016 the US Navy issued new, less restricting rules for tattoos. These new rules allowed for sailors to have 'multiple or large tattoos below the elbow or knee, including the wrists and hands'. This is quite the opposite of the US Government statement made in 1909 which stated: 'Indecent or obscene tattooing is cause for rejection ... The applicant should be given an opportunity to alter the design, in which event he may, if otherwise qualified, be accepted.'

Tattooing has been linked with the navy for centuries. This tradition began in the 1700s when Captain Cook discovered the tattooed natives of the South Pacific. Cook's sailors were looking for the perfect memento of their journey into foreign lands, and a tattoo was the most exotic souvenir they could bring home.

Below are some of the meanings behind the sailor tattoo:

HOLD, on the knuckles of one hand and **FAST** on the other. This is said to help the seaman to better hold onto the rigging.

A **pig** on the top of one foot and a **hen** on the other. This is said to protect the seaman from drowning, because neither of these animals can swim, so they would get the seaman quickly to shore and save them.

An anchor was one of the most popular sailor tattoos, showing the wearer had worked as a seaman.

A **full-rigged ship** identified a seaman who had sailed around Cape Horn.

A **dragon** identified a seaman who had served in China.

A **golden dragon** identifies a seaman who has crossed the International Date Line.

A **shellback turtle** is worn by a seaman who has crossed the equator.

Port and **starboard ship lights** were tattooed on the left (port) and right (starboard) side of the body.

Rope tattooed around the wrist identifies the seaman as being a deckhand.

Miss Eleanor Barnes of the Seaman's Institute once remarked: 'Some people pour out their colourful stories to juries. Others relieve the tension by writing for the confession magazines. The sailor enlists the tattooist's needle upon his own body in dull blues, vivid reds, greens and yellows to record the story of his loves and hates, his triumphs, his religion, and his patriotism.'

Rose and Flower Designs

Throughout tattoo history there are few designs that have more meaning than a rose or flower. Each flower has different meanings to the wearer and hidden messages are concealed within the design. The language of flowers has long captivated the wearers of these tattoos and continues to be popular today.

The meanings behind a flower tattoo can change and differ from culture to culture. It is advisable to always carry out some research when thinking of a new tattoo design in order to learn of any connotations that a certain design may have.

It would be virtually impossible to give all the meanings and symbols represented by all of the flowers all over the world. However, what follows are the beliefs behind some of the most popular flower designs used in tattoos:

Roses originated in ancient Persia and they were first recognised as masculine. However, over the years they have become associated with femininity, but remain popular with both men and women. There are 101 meanings associated with this flower, but for many it is used to simply represent love.

Lotus flowers, which are an increasingly popular design, represent knowledge, understanding, enlightenment and life.

Cherry blossom tattoos are very common in Japanese-style tattooing. The tattoo is often designed as falling petals being carried along in the wind, reflecting Japanese culture. The cherry blossom is fragile and beautiful but are not in flower for very long, with the beauty of the flower fading quickly. Many Japanese people look on this as a metaphor for life, with the flower echoing their own mortality.

Chrysanthemums are also significant in Japanese tattoo art. This flower has association with royalty, and especially the Emperor, who sits on the Chrysanthemum Throne, as the flower represents perfection. In China the flower it associated with Taoism and is a symbol of perfection and simplicity, as well as happiness and joy. There is also a connection with the time of year that it blooms, which is the autumn, and it is perceived as a symbolic representation of the transition from life to death (autumn to winter). Often in Chinese culture chrysanthemums are given at times of congratulations, good wishes and for longevity.

Flower designs have no doubt been the mainstay of the tattoo business for many centuries, with the rose being more popular than any other flower. Many tattoo artists have chosen to make a name for themselves with their own incredible rose designs.

Many rose designs show a baby or a young girl's head in the centre of the design, while other artists have gone even further.

It has been said that flower tattoos were used during the Second World War, hiding coded messages to get across the front line, and that they were a vital link in times of war.

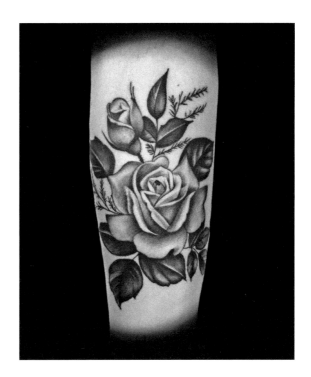

The rose can have many meanings, from love and deep devotion to joy and gratitude, and has been popular since ancient Persia. This black and grey rose is by Cally Jo.

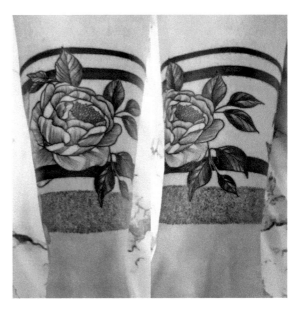

The rose is often used to symbolise balance. Roses by Claire Innit.

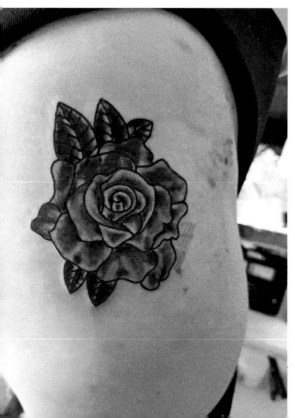

Above: A vintage design sheet, kindly supplied by Lal Hardy from a private collection.

Left: Flower designs are one of the most popular throughout tattoo history. (Design by Buddy, Living Art Tattoo)

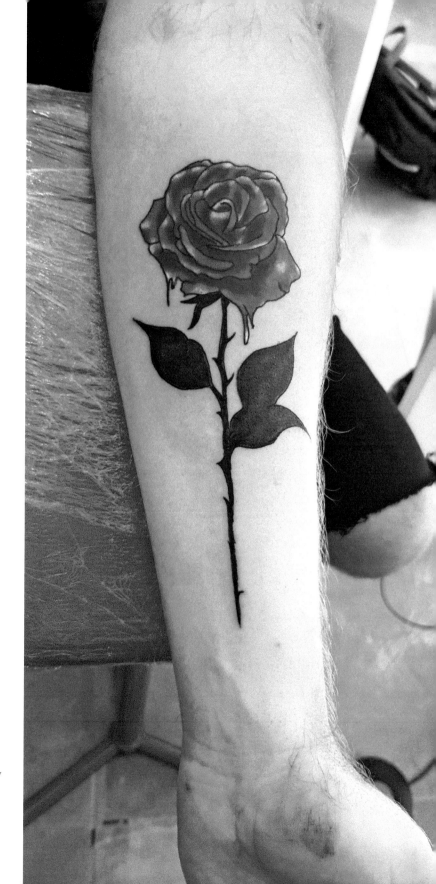

Each flower is unique and has its own hidden meaning for the wearer. (Design by Buddy, Living Art Tattoo)

Animal Marking and Identification Tattooing

The physical action of applying a tattoo is not just limited to humans, but has also played its own role in animal identification. Tattoo suppliers have always looked for more ways to market their products, and for decades have sold their machines as animal markers.

With a simple modification to the tube assembly, wherein a fingertip switch replaces the foot switch, these machines could be sold to veterinarians, medical labs and racehorse owners. It is necessary to modify the switch because tattooing is often performed in a barnyard and the foot switch would not work.

The marking of animals goes back to 2000 BC, when the Egyptians marked their cattle to prevent theft. This marking identified ownership and was often part of early historical records. When Spanish explorers brought the first cattle to North America in the sixteenth century, cattle branding became widespread. Often these brands could be the owner's initials or the name of the ranch. In most cases a brand on an animal was considered proof of ownership.

Cattle were not the only farm animals that were marked for identification. Back in the day when armies moved by horsepower, the military painted identification numbers on horses' hooves.

In the modern day, ensuring that a horse is easily identifiable goes a long way to recovering the horse if it is stolen. Visible identification marks can also act as a deterrent. Many insurance companies offer reduced premiums for horses that have some form of security marking on them. The horse is tattooed on the upper lip with a letter, indicating the horse's year of birth, and four or five numbers. Tattoo identification services assist owners and agents of thoroughbred racehorses with identification. In the US, thoroughbred horses are required by most state racing rules to be tattooed in order to participate in an official race.

Dogs, rats, turkeys, chinchillas, rabbits, foxes, fish, monkeys and alligators are but a few of the animals that have been tattooed for the sake of identification. Before the modern microchip came along, tattooing dogs was very common and some breeds were even required to be tattooed. Dog owners had a registry for these numbers and I have heard many a story of a family's beloved lost pet being returned because of these numbers.

Besides marking animals for identification, some pet owners have taken it to a more decorative level, tattooing their pets with attractive designs. Lyle Tuttle's dog Chadwick had a heart with the word 'mother' tattooed on his inner thigh and in the 1950s Milton Zeis tattooed Jenifer the monkey with an anchor and ship. Frank Graf, a 1920s Coney Island tattooist, is said to have tattooed a cow, which was displayed in the sideshow. Let's not forget the Tattooed Pig and Hairless Dog Project (1976–84), created by Andy Feehan. Tattooist Randy Adams and Stanley Marsh III, a millionaire, artist, philanthropist and prankster from Amarillo, Texas, were also involved in the project. Marsh provided the money and Adams the artist vision.

Religion and Tattoos

Early Christians often had the sign of the cross tattooed on their bodies, particularly on their face or arms, and they sometimes also had a small tattoo on the inside of their wrist. Such tattoos were seen as a permanent mark of and commitment to the faith. However, around AD 325 the Emperor Constantine outlawed tattooing of the face because he believed that the face was in God's image and should not be disfigured. In AD 787 a council of churches renounced all forms of tattooing, sealing the fate of the practice in the eyes of the Christian Church.

Later, however, the Knights of St John of Malta sported tattoos to show their allegiance. Later still, a representation of the crucifixion tattooed on a slave's back was said to preserve the bearer from a whipping. It was thought that no Christian, however cruel, would slash the image of Christ. Nowadays, there is no prohibition against tattooing within the Catholic Church, provided that the tattoo is not an image directly opposed to Catholic teaching or religious sentiment.

Due to Sharia law, the majority of Sunni Muslims hold that tattooing is religiously forbidden. The view is that the human form was created beautiful and therefore should not be changed in any way. Tattoos are permissible in Shia Islam, though.

In Judaism tattoos are forbidden based on the Torah, which states: 'You shall not make gashes in your flesh for the dead, or incise any mark on yourselves.' There is also a general prohibition on body modification that does not serve a medical purpose.

However, the thoughts of the Neopagan are that you can use the process and the outcome of tattooing as an expression or representation of belief. Many pagan images are offered as artwork, and these are very popular. In Wicca, a tattoo is used as a mark of initiation.

In Hinduism, many women tattoo their faces with several dots around the chin and eyes to ward off evil and enhance their beauty. Tattoos are also used to distinguish between ethnic groups and clans. Many Hindu men and women tattoo the Om or Aum symbol on their hands or arms. There is great belief in this symbol, which is said to protect from evil and bad karma.

History of the Equipment and Inks

The history of the equipment and inks is almost as intriguing as the history behind the art itself. In the beginning, all tattoos were done in black. Once humans had fire, they had soot that, when mixed with water, turned into a pigment that could be pushed into the skin. Black was the only pigment in tattooing for centuries. In August 2013, a gentleman from London was tattooed with a portrait of his late father with a mix of ink and a small portion of his father's ashes. Today, in US prisons, all manner of items are burnt to create the black pigment, from a mixture of baby oil and chess pieces to foam cups – there is no end to the creativity of the tattoo artist.

Early colouring materials for tattoos included soot or ink for blue-black and brick dust for reds. To work, these needed to be bound together by a mixing agent. Often the tattooist used his own spittle to mix the colour, but occasionally urine was used instead. Until 1891, when the first electric tattooing machine was patented by Tom Riley, all colours were applied by hand. Early tattooing tools were rather like pen holders with a number of needles set into them.

The date when the tattooist's palette expanded to more than black is lost in history, but the popular consensus is that red was the second colour added, and shortly thereafter green, brown, and yellow came on board. Ingenious tattooists, often experimenting on their own bodies and through a system of trial and error, discovered these colours. Many artists wrote to chemical companies requesting samples to try and create the best pigments for tattooing; however, many hid the intended use from the companies as they worried that they would not sell to them if they knew it was required for tattooing. Many companies were concerned that their products would be used in tattooing and they feared the legal liability that might follow after putting this pigment into human skin.

The following is an excerpt from Percy Waters' 1925 catalogue, talking about his pigment and how to mix it:

Use only the best colours purchased from reliable dealers. They are chemically pure and harmless to the skin, while imitation colours sold by so-called importers are nothing more than common house paint, and likely poison. Genuine colours are seldom found among the beginners, as they, not knowing the difference, use what they are told, or perhaps buy them at

a far higher price. The best colours are used by the old time tattooists, who know the kind to buy as well as they know a bright coloured tattoo will bring them business.

To mix colours right and get best results, red, yellow, and brown, mix by using ½ Listerine and ½ distilled water. Green, light or bright green, mix by using only distilled water. You should be careful to mix well, about the thickness of cream, but not too thick. The green will work better if a trifle thinner.

For the past 150 years, this was pretty much the formula for colour, though now and again a tattooist would come up with a formula that they thought was better. The general rule for colour mixing is keeping the additives simple. During this era, the first thing you would notice when walking into a tattoo shop was the smell of Listerine. During this time tattooists worked straight out of the opal glass jars their pigments were kept in with little knowledge of, or concern about, cross-contamination.

Milton Zeis, working in the early twentieth century, was one of the first tattoo suppliers to offer pre-mixed pigment and individual colour caps. He offered fourteen different pre-mixed colours in screw-top eye dropper bottles. Today, we have what could be called a full-colour palette. Modern tattoo suppliers offer pigments with a range of gimmicks, including glow-in-the-dark, metallic colours and microorganism resistant inks. Today it is important that inks are nontoxic, sterile and approved by the relevant authorities, as well as being freshly made with body-friendly ingredients. That is not to say there haven't been problems with pigment reactions in modern times, however. In the last decade some major tattoo suppliers have been sued for exposing people to unhealthy levels of lead and other metals without warning.

Who Invented the Tattoo Machine?

Thomas Edison (1847–1932), the inventor, created an electric pen for creating embroidery patterns in 1876, which he patented under the name Stencil-Pens. Then, in 1891, Samuel O'Reilly discovered that Edison's machine could be used to introduce ink into the skin, later patenting a tube and needle system to provide an ink reservoir. Modern tattooing machines use electromagnets, with tattoo artists working with several machines, each being used to inject a different colour. The number of needles set in the machine and their fineness depends on what the machine is being used for, with fine needles being used for outlines and coarser needles for shading.

The speed and accuracy of delivering ink to the skin has evolved over time, and the inks and pigments used have also changed. There are many new methods being developed and with the benefit of the digital age, the knowledge of machine builders is increasing exponentially. Even with all the advancements in tattooing, it is not uncommon to still see tattoos being applied traditionally and ritualistically in places like Japan and Samoa, in the same way that has been used for centuries.

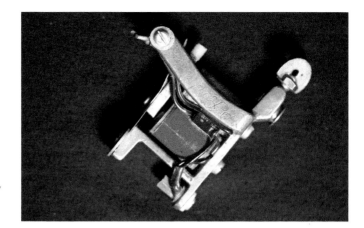

Tattoo gun of the kind Paul Rogers used in the USA, *c.* 1970s, kindly supplied by Lal Hardy from a private collection.

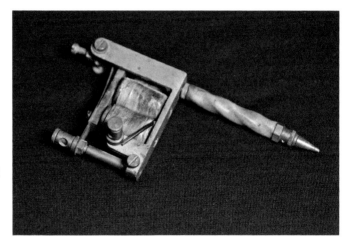

Tattoo gun of the kind David Burchett used in the UK, *c.* 1960s, kindly supplied by Lal Hardy from a private collection.

New Wave Tattoo interior, *c.* early 2000s, kindly supplied by Lal Hardy from a private collection.

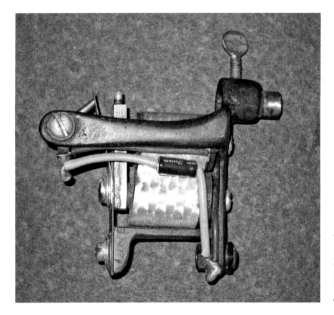

Vintage tattoo machine of the kind Paul Rogers used in the USA *c.* 1970s, kindly supplied by Lal Hardy from a private collection.

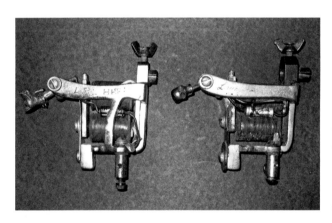

Vintage tattoo machines with wolf and skull designs, used in the USA by Nick Picaro, *c.* 1960s, and kindly supplied by Lal Hardy from a private collection.

Tattoo Removal

Many people have been there; they thought that getting a certain design was a great idea at the time, but time passes and the love or the motive has gone and so has the reason for getting the design in the first place. At this point many people opt for tattoo removal, which can cost up to three times more than the design itself. They are, however, difficult to remove and it should not be something that is ventured into lightly due to how deeply within the skin the ink lays.

Early ways of removing tattoos included injecting wine into the skin, and also the application of lime, garlic or pigeon excrement – thank goodness techniques have developed! None of these methods were very effective in removing the pigment. Other more recent methods include dermabrasion, which in effect is when the skin is sanded

down and the tattoo image is surgically removed. This method does, however, result in extensive scarring.

In the late 1980s laser surgery became popular for tattoo removal. However, the treatment is not cheap and can cost thousands of pounds, depending on the tattoo's size, type and location.

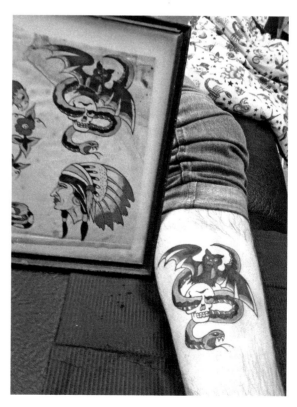

Above: A tattooist's business card, kindly supplied by Lal Hardy from a private collection.

Right: A bat and serpent design, kindly supplied by Lal Hardy from a private collection.

Medical Tattoos

For centuries tattooing has had alternative benefits than the visual we have all become used to and this includes its use in medicine. Medicinal tattooing was used in Cairo in 1898 as a treatment for women who were suffering from various pelvic conditions. It was believed that the tattooing would relieve the unbearable pressure and thus the pain experienced. Medical articles from the 1900s wrote about cases of tuberculosis inoculation from tattooing and how the deadly disease was spread in this way.

In Polynesian societies it is the actual pain felt during the practice of tattooing that is said to cure certain medical problems. In Samoa, tattooing was used as a distraction for certain medical procedures; for example, during childbirth.

Many people are unaware of the medical side of tattooing and the way in which it is used to help recovery from certain medical procedures. Medical tattooing is sometimes offered after surgical procedures to aid with the healing process, or to add pigment back into a patient's skin following a procedure. I spoke with Dawn Forshaw from Finishing Touches, asking her to explain how tattoos have assisted so many people's recovery.

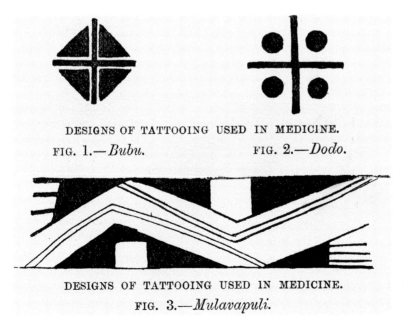

DESIGNS OF TATTOOING USED IN MEDICINE.
FIG. 1.—*Bubu.* FIG. 2.—*Dodo.*

DESIGNS OF TATTOOING USED IN MEDICINE.
FIG. 3.—*Mulavapuli.*

Tattoo designs used in medicine (date unknown). (Image courtesy to The Wellcome Collection)

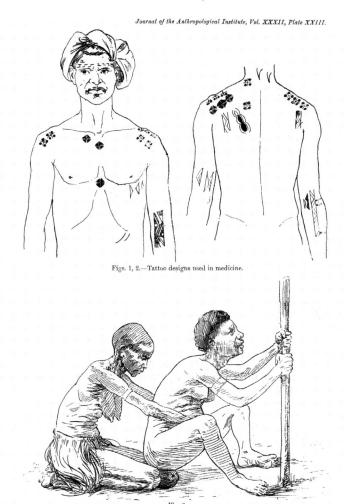

Journal of the Anthropological Institute, Vol. XXXII, Plate XXIII.

Figs. 1, 2.—Tattoo designs used in medicine.

Fig. 3.

THE MEDICINE AND SURGERY OF THE SINAUGOLO.

Illustration of tattoo designs used in medicine.

Dawn explained that she has dedicated much of her working career to micropigmentation. She has over twenty years' experience and Finishing Touches is one of the world's leading companies in all areas of micropigmentation, offering training in permanent cosmetics, SPMU and scalp tattooing, and offering medical procedures (including areola restoration and pigmentation) and all areas of skin rejuvenation using needles.

Dawn is proud of her micropigmentation journey, which started back in 1996. Having taught some of the industry's best, Dawn has a unique approach that inspires newcomers to the industry and encourages practising technicians to strive for procedural excellence. Dawn has been one of the first to attain acceptance for setting standards and raising safety in the micropigmentation industry. Dawn's dedication to the industry shines through. As well as providing this groundbreaking service, Finishing Touches also trains individuals to provide tattooing to a very high standard.

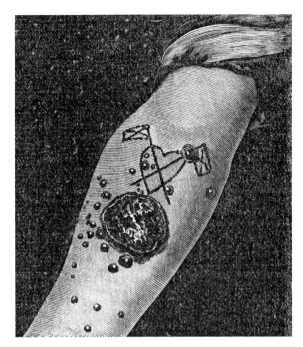

An illustration from 'Three Cases of Inoculation of Tuberculosis from Tattooing', showing the perils of contaminated tattooing. (Image kindly supplied by The Wellcome Trust)

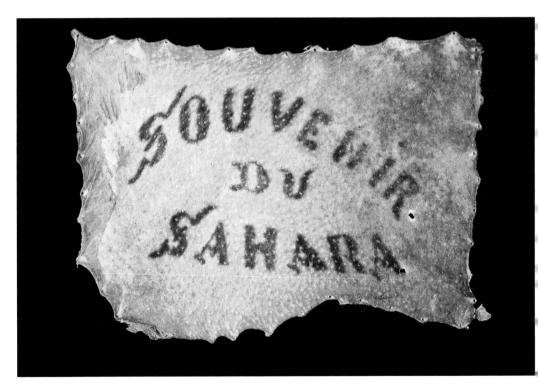

Human skin tattooed with an inscription reading 'Souvenir Du Sahara', *c.* 1830–1900. (Image kindly supplied by The Wellcome Trust)

Tattoo Schools, Museums, Festivals and Television Shows

There is little doubt today that the tattoo world has international appeal and following. There are countless social media platforms overflowing with the most magnificent designs from all over the world. Magazines such as *Inked* and *Skin & Ink* are market favourites, offering an insight into the world of tattoos to a sector of the population addicted to this ancient art form. Many have written about the subject of tattooing.

Across the globe there are hundreds of tattoo festivals and conventions held each year, which showcase some of the best in the business.

Pierced Hearts and True Love, a tattooing book kindly supplied by Lal Hardy from a private collection.

Above left: Ink and Tattoo Convention, 2013 – one of the many conventions which have popped up worldwide over the last ten years.

Above right: *Skin Deep*, a tattooing book kindly supplied by Lal Hardy from a private collection.

Television shows such as *LA Ink*, *Miami Ink* and *New York Ink*, as well as *Ink Master*, have brought tattooing into the front rooms and lives of millions. These shows have inspired many, with tattoo artists today becoming celebrities in their own right.

Tattoo schools have popped up globally and one of the most famous of these was the one Milton Zeis assembled in the 1950s. This twenty-lesson mail order course was accredited by the state of Illinois and many old-time tattooists often mention this course in interviews – sometimes with disgust. Tattoo suppliers would always include some sort of written instructions with the equipment they sold. The Zeis home study course was just an expanded version of the written instructions offered by Percy Waters three decades earlier. Today there are tattoo schools in Limerick and London, to name but two, with outstanding teachers and results. It's amazing to see just how far the teaching of tattooing has come.

Across the world there have also been several tattoo museums, either physically or on the Internet, each offering a collection of useful and interesting information on the world of tattooing.

The London Tattoo Academy

Sabrina and Buddy are well known for their tattoo work, but are equally well known for opening the London Tattoo Academy. The London Academy was opened to give aspiring tattooists the opportunity to learn the correct techniques right from the start, to ensure they have the knowledge and know all of the safety aspects of tattooing. Buddy explained that this is now bringing tattooing to a whole new level; now you can learn from someone who has nearly thirty years of experience in a classroom environment. Tattoos are no longer a closed circle; now they are mainstream and attitudes have moved on. After all, why shouldn't everyone who is interested be able to learn? Why should it be an impossible business to get into? Teaching people the right way will make it safer for everyone.

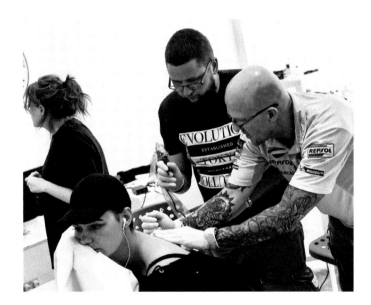

The London Tattoo Academy – training tattooists of the future.

The logo of the London Tattoo Academy.

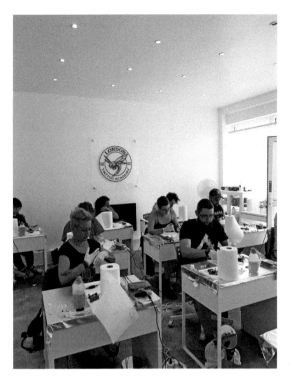

Students learning the art of tattooing at the London Tattoo Academy.

Buddy, the co-owner of the London Tattoo Academy.

Meet the Artists

During my research for this book I had the privilege of meeting some great tattoo artists and they have shared their stories with me. This chapter looks at a few of these artists and what inspired them to start tattooing.

Lal Hardy – New Wave Tattoo, London

Lal was born in Barnet in 1958 and has lived in London all of his life. His interest in tattoos came from seeing relatives who had served in the armed forces who had tattoos celebrating places visited during their service. Peter and Fred, his uncles, were both naval men who had sailing ship tattoos with 'Hong Kong' inscribed under them, while his Uncle Sandy had tattoos from Egypt and Malta.

As a child he would love to buy lick and stick tattoos from the local sweet shop. The images were of real traditional tattoo art and as a child he loved wearing these on his arms.

Lal Hardy, owner of New Wave Tattoo, London.

In the mid-1970s there was a huge teddy boy/rock 'n' roll revival in the UK and Lal would spend a lot of his time visiting dancehalls, pubs and clubs, dancing and listening to the rock music he loved dearly. It was at these events that he noticed many of the teddy boys with tattoos. As some of his friends had started getting tattoos, he began accompanying them to some studios. In 1976 Lal recalls that he visited Dave Cash's studio in Wood Green, North London, and paid the sum of £4 to have a panther's head and a dagger drawn on his skin. This was the start of it and various tattoos from numerous studios followed.

By 1978 he had started scratching (amateur tattooing), but was keen to learn and befriended a few tattooists who shared with Lal many of the secrets of the trade and snippets that would help him through his career.

With the advent of punk, especially the second generation, Lal began to become well known locally for catering for punks and other subculture tattoo requests.

New Wave Tattoo exterior, kindly supplied by Lal Hardy from a private collection.

'Tattoos Last Longer than Romance', kindly supplied by Lal Hardy from a private collection.

New Wave Tattoo, kindly supplied by Lal Hardy from a private collection.

Vintage Tattoo Expo tickets kindly supplied by Lal Hardy from a private collection.

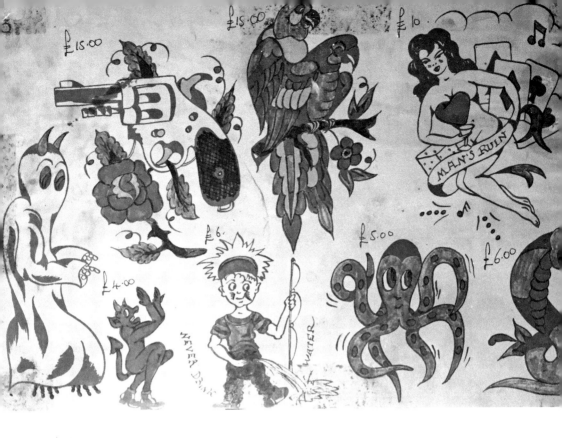

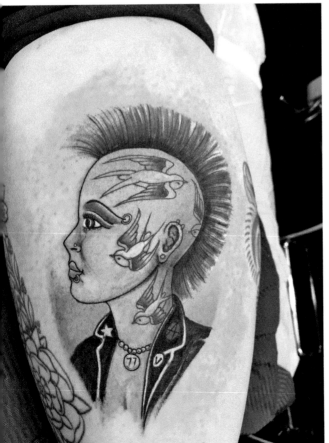

Above: Vintage tattoo designs, kindly supplied by Lal Hardy from a private collection.

Left: Punk design by Lal Hardy.

Lal proudly explained that in 1982, after four years of home tattooing, he opened New Wave Tattoo in Muswell Hill, London. New Wave has attracted many clients from near and far after many punk publications featured the studio on their pages. As the studio grew it became necessary to take on new artists to cope with the increase in trade. Over the years many artists and guest artists have brought their style and skills to New Wave Tattoo. Having artists of all styles at the studio has kept Lal's outlook on tattoos fresh and he has been able to see incredible talent from many talented individuals. Over forty years, Lal's tattoo journey has been incredible and he has travelled the world, tattooing and getting tattooed in different lands.

Lal has also been involved in the documentation of tattooing for museums, has made films celebrating tattoos and tattooed the rich and famous, but also thousands of everyday folk, and he feels so fortunate to have had the opportunity to be part of such an eclectic, vibrant and also ancient art form.

The tattoo parlour's website can be found at www.newwavetattoo.co.uk.

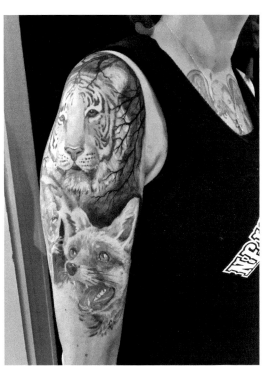 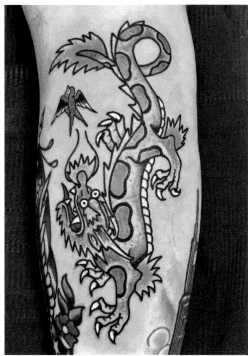

Above left: Black and grey animal design by Lal Hardy.

Above right: Dragons have long been a popular request and this design is of an Asian Dragon by Lal Hardy.

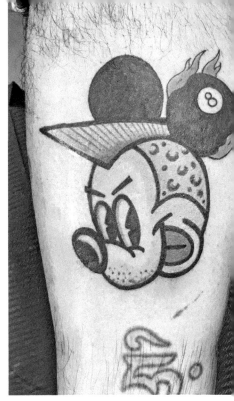

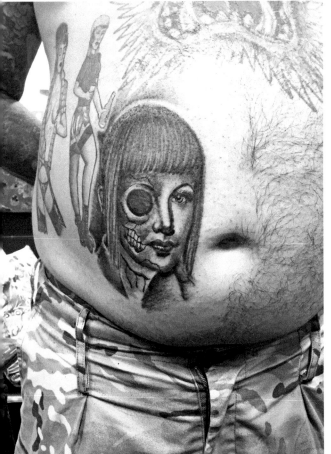

Above left: 'Don't Bite the Hand that Tattoos You' by Lal Hardy.

Above right: A Mickey Mouse design by Lal Hardy.

Left: An illustrated lady by Lal Hardy.

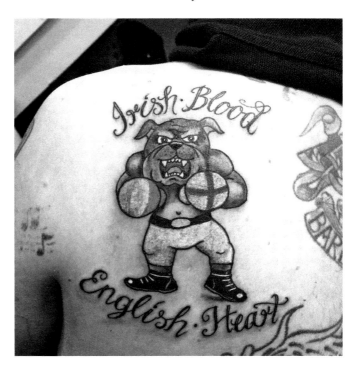

'Irish Blood' by Lal Hardy.

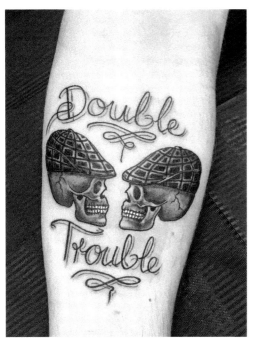

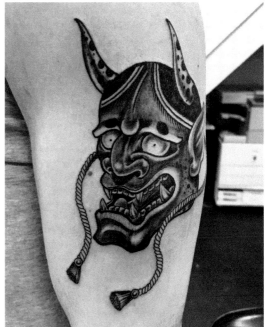

Above left: 'Double Trouble' by Lal Hardy.

Above right: A devil design by Lal Hardy.

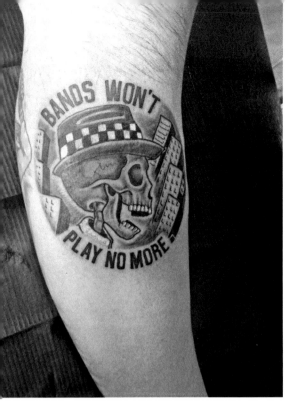

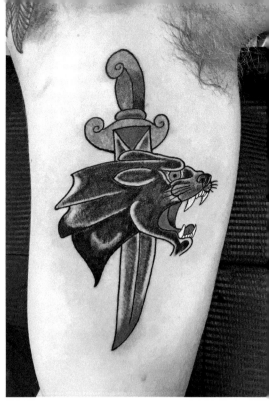

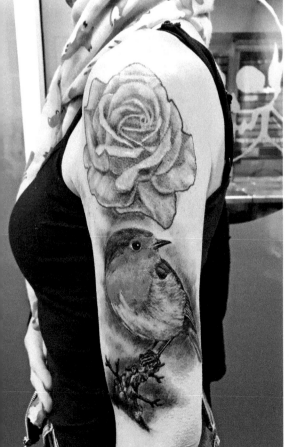

Above left: 'Bands Won't Play No More' by Lal Hardy.

Above right: A dagger and panther by Lal Hardy.

Left: Birds have long been a popular choice for British tattoo designs. Here we see a watercolour-styled robin by Lal Hardy.

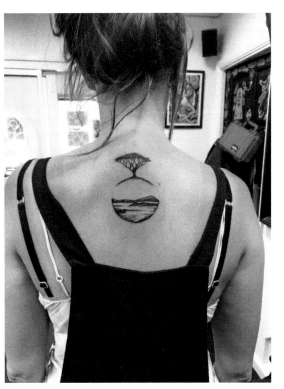

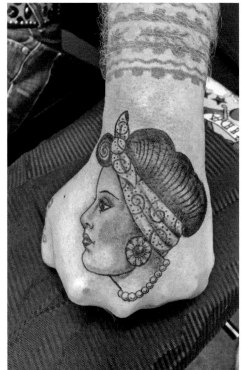

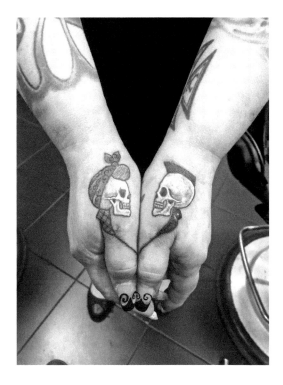

Above left: Trees have many meanings, from immortality and eternity to knowledge and wisdom, strength and protection. The tree of life is a popular design. This version is by Lal Hardy.

Above right: Gypsy tattoos are true old-school designs and are the perfect choice for any traditional sleeve or design. Gypsy by Lal Hardy.

Right: The skull has numerous meanings; however, it is quite powerful as a representation of life and death. Sometimes you can have a skull and a rose design together, denoting the contrast of life and death. Skulls by Lal Hardy.

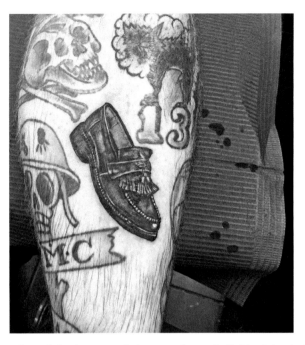

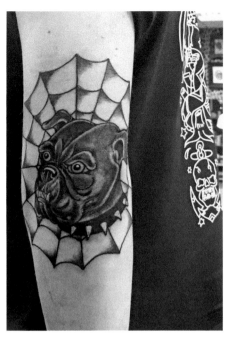

Above left: A tattoo design can be as individual in design as the wearer is. Shoe design by Lal Hardy.

Above right: Bulldog by Lal Hardy.

Sometimes it's just nice to have a fun cartoon-style tattoo. Weetabix cartoon design by Lal Hardy.

'Blue Devil' by Lal
Hardy.

Claire Bartlett – New Wave Tattoo, London

Claire, known as Claire Innit, dabbled in the tattoo scene when she was eighteen for a couple of years before moving away into plastering work for a while. Then she had the opportunity to manage a tattoo shop in Sheffield called Thou Art, which led to her apprenticeship at the age of thirty. She stayed there for a few years, while also working at a studio in Essex and New Wave Tattoo, in London. The commute eventually became too much and Claire moved to the south and she now works at New Wave Tattoo in London as well as in her own private studio in Essex.

She describes her style as open and loves black work and tribal. She also likes etching, line work, black and grey, and anything other than colour!

She has been inspired by many, including Dots to Lines, Nick Whybrow, Thomas Cooper, Curley, Matt Black, Lal Hardy, Jeff Gogue, Ryan Evans and Simon Erl – the list could go on.

'Love' by Claire Innit.

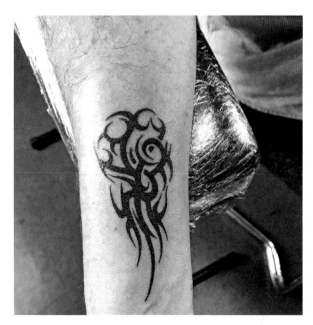

Many of these designs were worn by ancient tribes and were used as a way to identify one another. Celtic design by Claire Innit.

72

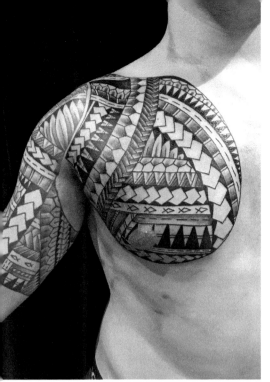
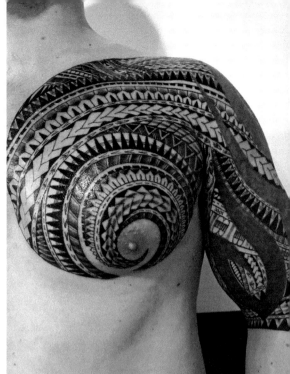

Above left and right: Full sleeve designs by Claire Innit.

Right: There are many bird designs in tattooing, with each having different meanings; for instance, doves are a symbol of Christianity and peace, whereas owls are to symbolise wisdom. Others are less philosophical or spiritual: the design here was inspired by the Tottenham Hotspur crest. Bird by Claire Innit.

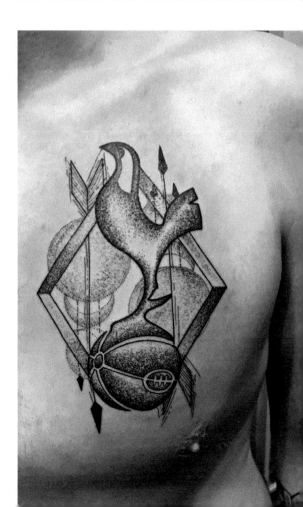

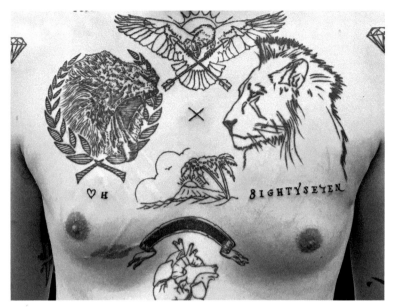

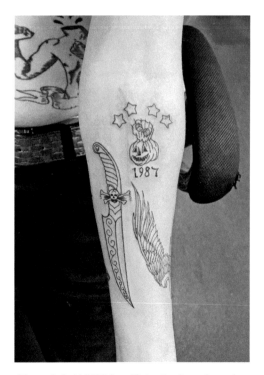

Black and grey chest piece by Claire Innit.

Above left: '1987' by Claire Innit – dates have always been used in tattooing, symbolising an important date or time in the individual's life.

Above right: Writing positioned down the arm by Claire Innit, showing the changes in tattoo design in more recent times.

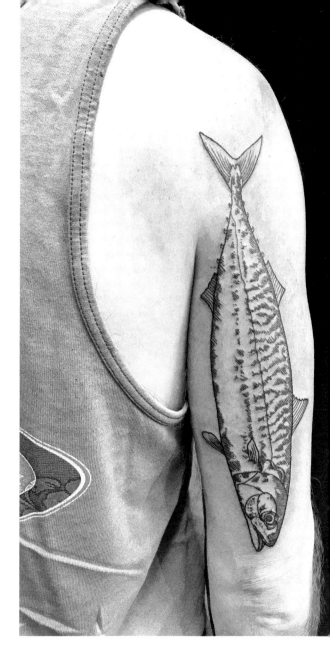

Fish designs have been used by many cultures as a symbol for overcoming adversity. Design by Claire Innit.

Gloria Weiß – New Wave Tattoo, London

Gloria Weiß, originally from Linz, Austria, currently works at New Wave Tattoo in London while also doing many guests spots throughout Germany and Austria. She started her tattoo career in 2010 and had her own tattoo shop called Human Canvas from 2013 to 2016. Gloria's speciality is black and grey realism, which she is passionate about, but she also offers other styles to her clients.

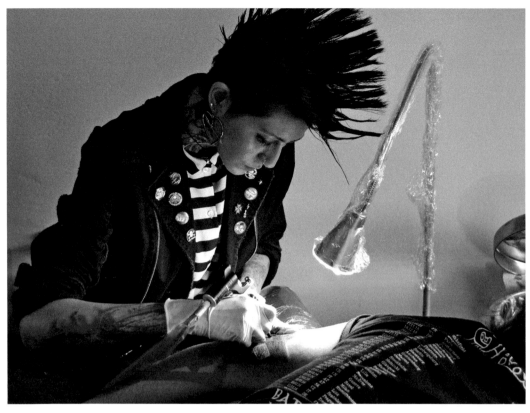

A tattooist working. (Image provided by Gloria Weiß)

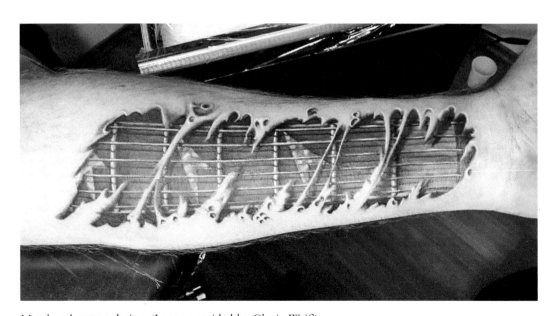

Metalwork tattoo design. (Image provided by Gloria Weiß)

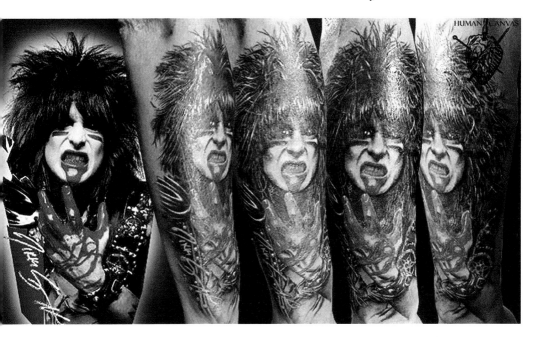

Above: A full-colour punk design. These images celebrate part of British culture and are as popular today as they have ever been. (Image provided by Gloria Weiß)

Right: Tribal tattoo design. Once the tattoos of ancient tribes, today they are one of the most popular designs. (Image provided by Gloria Weiß)

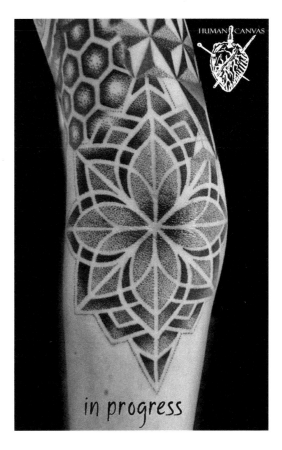

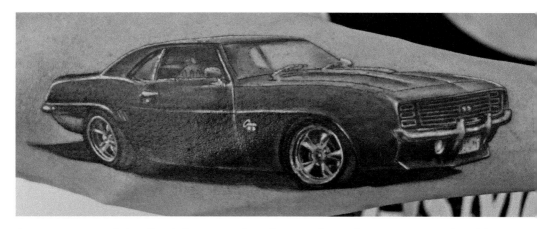

A motorcar tattoo design. People have a number of reasons for getting a tattoo; sometimes it's to keep a memory of something they love! (Image provided by Gloria Weiß)

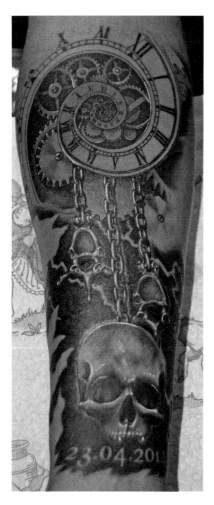

A tattoo design featuring a clock, skull and chains. Many tattoo designs have hidden meanings; this is nothing new, with the practice of gaining symbolic tattoos dating back centuries. (Image provided by Gloria Weiß)

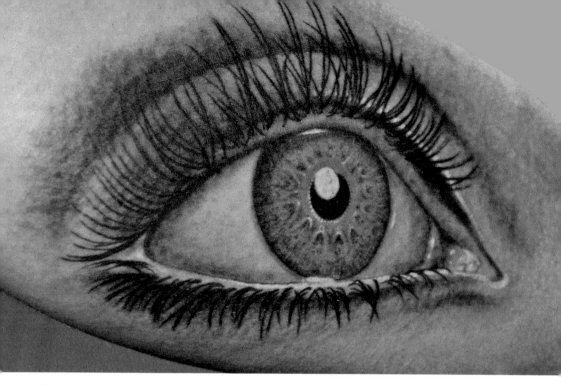

The image of an eye has been a popular choice since ancient times and is still popular today. (Image provided by Gloria Weiß)

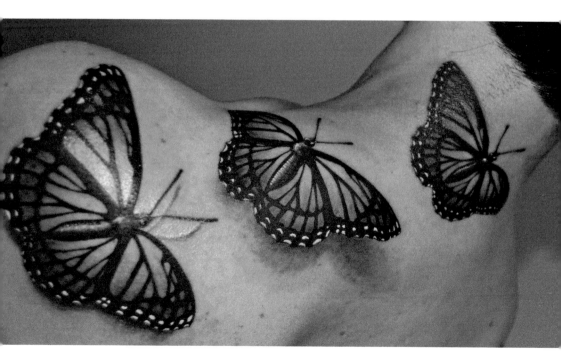

Butterflies are one of the most popular designs asked for as they have many meanings, one of them being to stay close to someone who has passed away. (Image provided by Gloria Weiß)

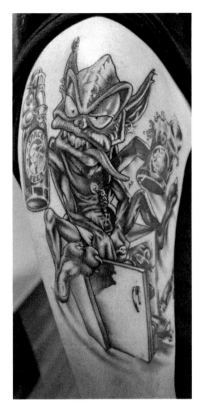

Tattoo designs come in all styles, shapes and sizes. (Image provided by Gloria Weiß)

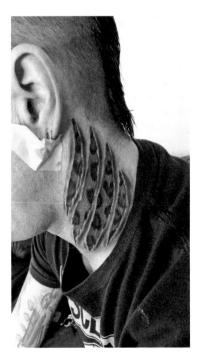

An example of photorealism tattooing. (Image provided by Gloria Weiß)

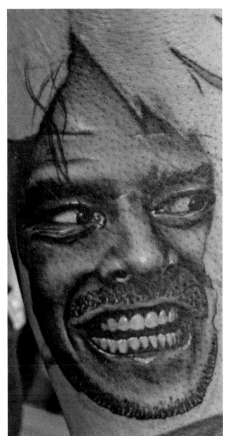 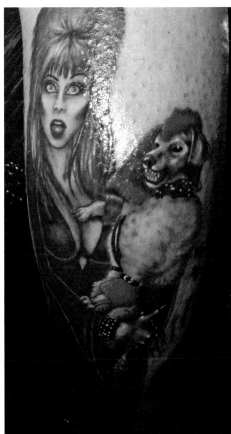

Above left, right and below: Fans of films will often ask for a tattoo linked to their favourite. (Image provided by Gloria Weiß)

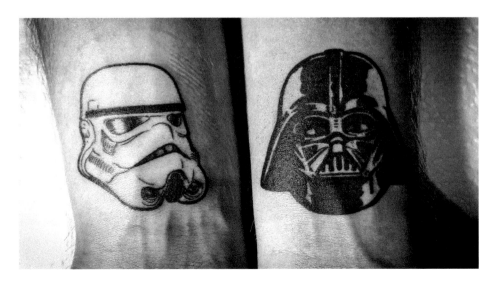

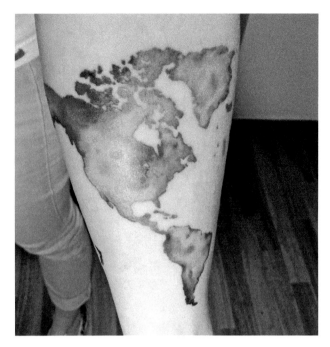

Places around the world hold meaning to many people, and what better way to show this than in a full-colour tattoo? (Image provided by Gloria Weiß)

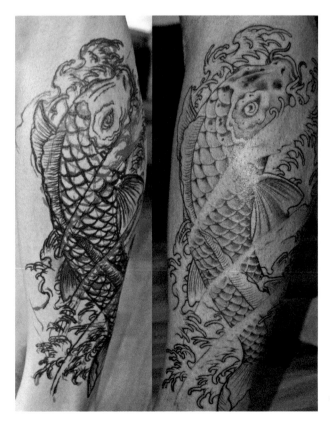

Koi has long been a much tattooed symbol from ancient Japanese art. (Image provided by Gloria Weiß)

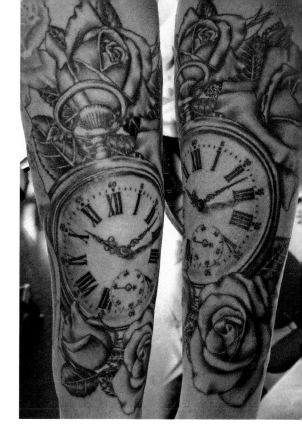

The image of a clock or watch is often chosen by someone who has done some time in a prison to mark the time they spent. (Image provided by Gloria Weiß)

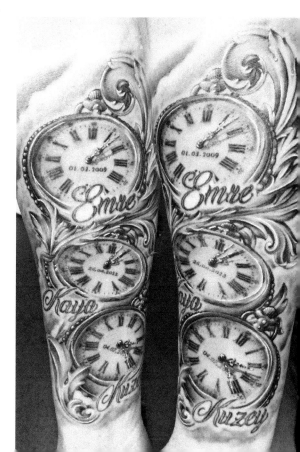

Tattoos can also be memorials to those we have lost. (Image provided by Gloria Weiß)

Sabrina and Buddy Moloney – Living Art Tattoo and London Tattoo Academy

Buddy is the proud owner of Living Art Tattoos, which is Limerick's first and longest standing tattoo studio since 1991. He worked as a motorbike courier in London in the late 1980s and it was during that time that he started to get tattoos of his own, developing a strong interest in the art form. After this, he decided it was what he wanted to do. Buddy then spent a couple of years trying to get someone to help him, it being a difficult industry to get into. Remember, this was at a time when there was no Internet and definitely no tattoo courses, just traditional tattoo apprentices. With his hopes of

ever becoming a tattooist fading, it was a trip to Sheffield during the summer of 1990 that changed his luck for the better when he come across Steel City Tattoo Studio and Dave, the owner. Buddy decided to get a tattoo from Dave and told him how difficult he was finding it to break into the business. Dave then offered Buddy help by letting him hang around his shop for a few days to gain some much-needed guidance.

Buddy brought tattooing to Limerick, opening the city's first tattoo studio. Since the doors opened in 1991 the business has flourished. Generations of families from Ireland and worldwide have come through Living Art's door, making this one of Limerick's busiest studios.

Sabrina is the co-owner of Living Art Tattoo and the London Tattoo Academy. She started her piercing career in 2000 and was taught by Buddy, who is now Sabrina's husband. Sabrina works full time in the piercing studio in between teaching piercing courses. She has a vast amount of knowledge of piercing and is passionate about her chosen career. She explained that it was not her lifelong dream to become a body piercer, and that she had actually somehow fallen into it, but she wouldn't change it for the world.

The lion symbolises immense power, strength and loyalty, so it's clear why it is a popular design choice. Full-colour lion by Buddy, Living Art Tattoo.

Living Art Tattoo.

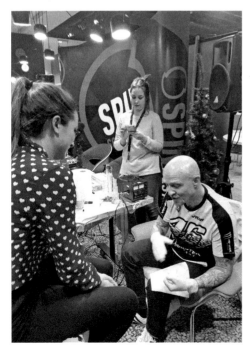

Living Art Tattoo took part in a live tattoo event on air to raise funds for a homeless charity.

The bee logo of Living Art Tattoo, London.

Equipment drawing by Buddy, Living Art Tattoo, London.

Buddy and Sabrina, owners of Living Art Tattoo, London.

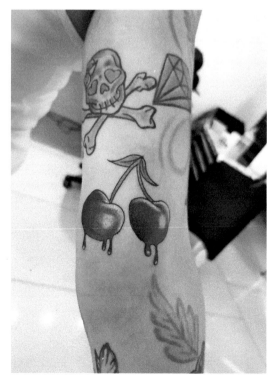

Full-colour tattoo designs by Living Art Tattoo, London.

The interior of Living Art Tattoo, offering a sneak peek of tattoos in progress at the studio.

Jimi May – Little Tokyo, Sydney

Jimi explained that he has always been interested in art and played in lots of bands. He wanted to tattoo from an early age but convincing his dad was not easy. When he finally got his dad's blessing, he decided to become an apprentice and approached Dee Why Tattoo, his local tattoo parlour, with his portfolio from art school. They invited Jimi in to sit in their shop and draw to see how he got on. The results were unbelievable, and he began tattooing there right away.

Jimi explained that he has always been super-creative. As he was in a band for many years, and finding himself around tattooed people and tattoo shops went hand in hand with being in music, he felt that it was a natural progression to move from music to tattoo art.

His first tattoo was a sacred heart on his arm, which he managed to convince his parents to get him for his eighteenth birthday. Most of his tattoos are fairly hidden, but he also has a huge back piece from his friend, artist Joel Ang, who has recently started a full sleeve of a tiger for him as well. A lot of his tattoos have Indian influence as it was one of his favourite places that he has travelled to.

Jimi feels that he tattoos similar to how he draws, which is mostly black and grey portraiture and realism. He loves tattooing animals, faces and statues – anything he can make look like a photograph on the skin.

Tattooing allows Jimi to work with many interesting people. One that stands out for him was a lady he tattooed while filming *Bondi Ink* who works for an amazing organisation called Sea Shepherd, putting her life on the line to save and protect marine life in affected areas, such as Taiji in Japan. Her story really stuck with Jimi and he informed me that it is people like her that make his job so rewarding.

Jimi hasn't been tattooing for a long time but he has seen a change since the world of social media has blown up. The Australian Government recently enforced new laws covering tattoo licensing, which have had a big impact on the industry. It's no longer quite as easy for new people to start tattooing in Australia now, but Jimi is of the opinion that it helps make sure that only serious artists can learn how to tattoo.

Jimi May, a tattoo artist from Australia.

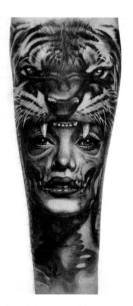
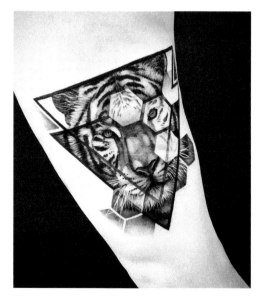

Above left and right: Two different designs featuring tigers by Jimi May.

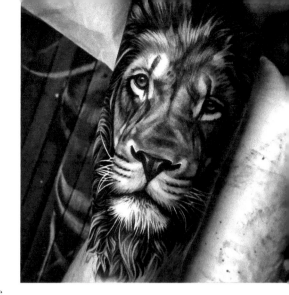

Amazing lion tattoos by Jimi May. Animals are a favourite tattoo for many artists to design.

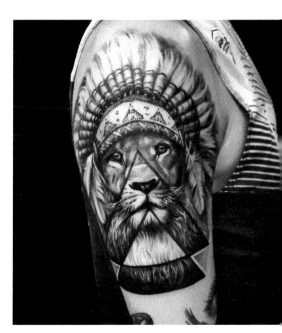

Cally Jo – A Travelling Tattoo Artist from Southampton, England

Cally explained that she got her first tattoo machine as soon as she turned eighteen, and started tattooing the friends and family members who let her practice on them while she was learning the skill. She always loved body art growing up and by the time she started tattooing she was already covered in piercings and had a few hand-poked tattoos. She knew it was the career she wanted as soon as she first walked into a tattoo shop.

Growing up she was surrounded by tattoo art – her parents, and even her grandpa had tattoos – and being a bit of a punk-rock kid, all of her friends were covered in tattoos, with them hanging out in the local tattoo shops. She explained that as soon as she graduated art school she turned to a friend to give her an apprenticeship and she started learning the following week.

From there she was approached by some amazing artists in Southampton and in London, and as time went on she learned from a lot of different artists in a lot of different styles. She feels that this is how she can appreciate all styles of tattooing, despite the fact that Cally usually only works in black and grey, and she only does perhaps one colour tattoo a year. Before she started tattooing she worked in nothing but pencil, so she has always loved greyscale; she thinks it has a timeless look to it and loves how it translates into skin.

Cally explained that tattooing has brought her many amazing opportunities and experiences over the last six years, from television shows to magazine covers. One event that always sticks with her is getting her first tattoo machine. She had been borrowing tattoo machines through most of her apprenticeship and she had fallen in love with the machines of Aaron Cain, one of which she been practicing with. She was sick in hospital at one point and her mentor at the time gifted her with her first machine, which was an Aaron Cain coil. It's still one of her favourite machines today.

Cally has a lot of her body covered in tattoos and she has a lot of different styles, from old-school to realism. She loves all styles and loves getting tattooed by her friends, and her favourite tattoos are actually most of her smallest ones. She loves the tattoos on her knuckles, where she has little crosses, symbols and numbers, which all have meanings to her.

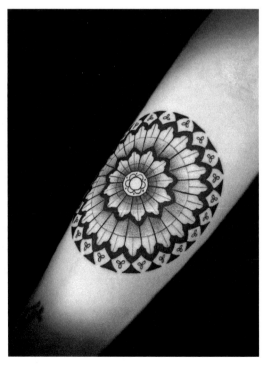

An intricate design by Cally Jo in black and grey.

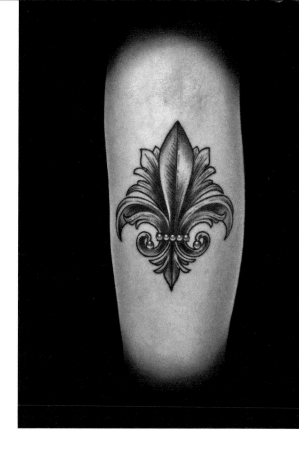

A black and grey fleur-de-lis by Cally Jo.

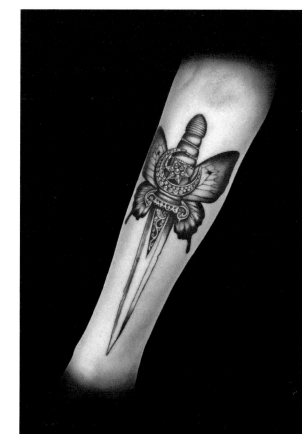

Another black and grey design by Cally Jo,
this time showing a beautiful butterfly
and dagger design.

About the Author

Tina Brown was born and brought up in Hastings, East Sussex, and has always had a passion for history. Tina has her own tour guide business, which she started in 1992, and prides herself on designing and providing bespoke high-quality guided tours, street theatre and talks, which Tina researches, writes and produces herself. She believes in bringing history to life in unique and memorable ways, always being mindful that today's events are tomorrow's history. She can be contacted via her website at www.historicexperiences.com.

Bibliography

Albert, Parry, *Tattoo Secrets of a Strange Art* (USA: Dover Publications, 2013).

Ancient Mysteries: *Tattooing* (with Leonard Nimoy, original air date 7 August 1997).

Hidden In America: Prison Ink (2016).

www.tattooarchive.com

Acknowledgements

The author and publisher would like to thank the following people and organisations for permission to use copyright material in this book: The Wellcome Trust; The British Museum; The British Newspaper Archive; Bodmin Gaol; The Tattoo Archive; Cornwall County Archives; Mack Jones, Darrell Boyd and James Roddy of Hays State Prison, Georgia; Finishing Touches; New Wave Tattoo, London; the London Tattoo Academy; Jimi May; Gloria Weiß; Claire Innit; and Lal Hardy of New Wave Tattoo.

Every attempt has been made to seek the permission for copyright material used in this book. However, if we have inadvertently used copyright material without permission or acknowledgement, we apologise and will make the necessary correction at the first opportunity.